IMAGES OF ENGLAND

TUNSTALL

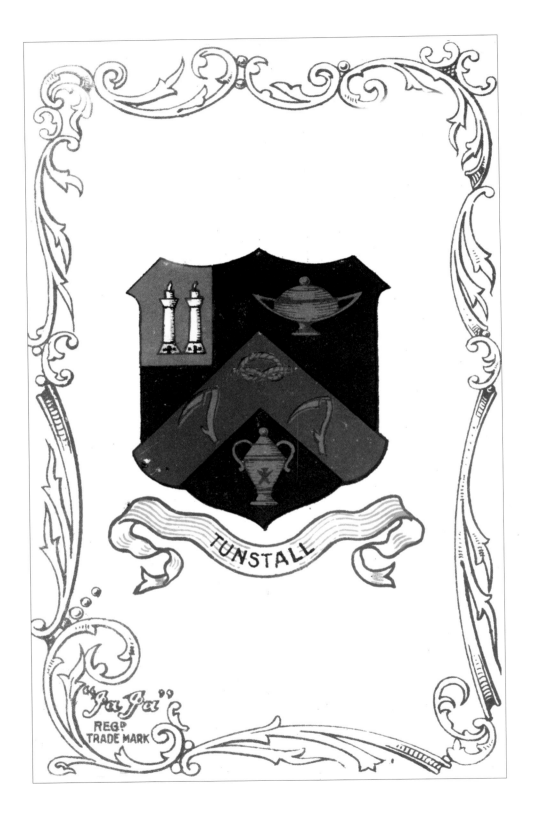

TUNSTALL

IMAGES OF ENGLAND

TUNSTALL

DON HENSHALL

TEMPUS

Frontispiece: Each of the six pottery towns had their own coat of arms and examples of them can still be seen incorporated in relief carvings on some of their public buildings. Tunstall's is above the main doorway on the Victorian Institute (now the library) in the Boulevard.

First published 2005
Reprinted 2007

Tempus Publishing Limited
Cirencester Road, Chalford,
Stroud, Gloucestershire, GL6 8PE
www.tempus-publishing.com

© Don Henshall, 2005

The right of Don Henshall to be identified as the Author
of this work has been asserted in accordance with the
Copyrights, Designs and Patents Act 1988.

British Library Cataloguing in Publication Data.
A catalogue record for this book is available from the British Library.

ISBN 978 0 7524 3721 7

Typesetting and origination by Tempus Publishing Limited.
Printed in Great Britain.

Contents

Acknowledgements

Whilst the majority of illustrations in this book are from my own collection of postcards, photographs, local books and ephemera, I would like to acknowledge the loan of material and assistance from the following people to whom I am extremely grateful for their support. Who knows, we may be able to gather some more together for a second volume.

David and Margaret Mycock of Abacus Books & Cards, Milton; George and Marion Owen; Imelda Cerioni, Mary Lomas and Brigid Warnock; Jackie Farrell; John Abberley, *The Way We Were* etc.; John and Sue Richardson; Michael Owen; Roger Simmons; Selwyn Viggars and Paul Atkins; Vera Ballard; Sheila Broad; Teresa and George Baddeley; Tony and Joy Priestley; Members of the Potteries Postcard Society; Various members of The Churches Together in Tunstall and, in particular, parishioners of the Sacred Heart Catholic Church, Tunstall.

Thank you also to anyone else who has helped, inspired or encouraged me in any way to form my collection and be able to share this with readers now.

I am indebted to the several authors who, over the years, have painstakingly researched many documents and recorded the facts, thus creating reference books for the benefit of past and future generations. They are the unsung heroes in the field of social history.

Finally, to my wife Juliana and daughters Christie and Naomi, for their tolerance and patience in helping me to prepare the book and realise my dream.

All reasonable steps have been taken to identify the owners of copyright to the photographs etc. and unacknowledged copyright holders are welcome to contact us.

Introduction

Tunstall is the northernmost of the six towns which combine to form the city of Stoke-on-Trent. It is an ancient manor court and there is mention of it as far back as 1086. Court rolls survive from 1326 and the expanding village passed through the hands of several lordships. Records show that by the 1200s the village remained with the Audley family and part eventually passed to the Sneyds in 1560, with whom it remained for some 200 years. There is much historical detail contained in the *Victoria History of the County of Stafford* which was published in 1963 for the University of London Institute of Historical Research. This was reprinted in 1981 by Staffordshire County Library and any reader wishing to further his or her knowledge of this fine history is hereby directed to that source.

There was rapid transformation from village to town as manufacturing industry sprang up. An abundance of coal and plentiful supplies of clay in the area fed the pottery industry. Small domestic potters were soon expanding into commercial enterprises. Earthenware and porcelain were the staple products, but brick and tile factories were formed and extensive iron foundries, chemical works and collieries all contributed to the wealth and growth of Tunstall. The population in 1811 was 1,677; by 1861 this had risen to 11,207. A canal system built in the eighteenth century by James Brindley helped the potteries deliver their wares throughout the length and breadth of the country with minimum breakages. Returning barges often brought other necessary raw materials, such as china clay from Cornwall. The advent of the railways in the late nineteenth century and the creation of a local 'loop line' linked Tunstall with the other five towns and beyond.

The six towns continued to grow and expand and it was considered sensible to amalgamate them into a Federation of Pottery Towns. The idea was first discussed in 1817 and the first serious attempt at creating the Federation was made between 1900 and 1903. Interest waned but further discussions started to take place and the towns began to make headway in 1905. In the meantime, Tunstall had extended its boundaries in 1899 to include Chell Heath and again in 1904 to include Goldenhill, and now it held out so as to secure the best terms for its entire people. Slowly it began to show its support for federation and the overall plan gathered momentum. After much scrutiny and discussion, the Bill travelled through the House of Commons and the House of

Lords and finally received royal assent. On 31 March 1910 the new county borough of Stoke-on-Trent came into existence.

On 5 July 1925, when King George V was visiting the North Staffordshire Royal Infirmary at Stoke to lay the foundation stone of extensions to the hospital, he announced that he was to confer the title and status of a city upon the Borough of Stoke-on-Trent. At the same time the title of Lord Mayor was to replace that of Mayor.

Initially, meetings of the new council were planned to be held at each town in turn but this did not prove successful and at the 27 October 1925 meeting at Stoke Town Hall it was agreed to hold all future meetings there, where they have remained to date.

Federation only centralised the administration of each of the six towns. Even today, each one still retains its unique characteristics. The public buildings built in the nineteenth century exemplified the wealth of each town, and they still remain centres of activity in the life of each one. Many were built to commemorate Queen Victoria's Jubilee and bear her name.

Stoke-on-Trent people are noted for being insular. They still refer to coming from Tunstall, Burslem, Hanley, etc. rather than Stoke-on-Trent, so reference is often made not of *one* city, or *six* towns, but of *thirty* or more villages! Families tend to remain within the boundaries of the towns, albeit a bit further removed from the centre, and can trace ancestors back through several generations. Family history survives and there is a definite sense of belonging. Tunstall is no different in this respect.

Religion has also been important to the town and there are still active congregations filling the pews and benches of the Anglican, Catholic, Methodist and United Reform churches and chapels. The Salvation Army has also had a long presence in the town and its band makes a useful addition to any joint celebrations.

Methodism came to the Potteries around 1741/42. John Wesley first preached in Burslem in 1760 and visited sixteen times over the next thirty years. By the time of his death in 1791 there was already an active congregation and church in Tunstall. Many divisions existed between the various Methodist strongholds. One such division occurred in 1807 when reports reached the Potteries of open-air meetings in America which lasted several days, with people attending camped out in tents. A visitor from America preaching of these camp meetings captured the imagination of Hugh Bourne and William Clowes, who held their first meeting in the open air at Mow Cop on 31 May. A few weeks later, on Sunday 19 July 1807, the second camp meeting took place. The Burslem Circuit became alarmed and expressed their opposition. As a result of their continued involvement, Hugh Bourne and William Clowes were no longer welcome in the Circuit. Bourne left in 1808 and Clowes two years later in 1810. Thus was formed the Primitive Methodist Movement; the first chapel was built in Tunstall in 1811 and became the centre of the Primitive Methodist Connexion.

The Anglican parish church is Christ Church. This was consecrated on 14 August 1832 and was formed into an ecclesiastical parish in 1837. Previously people had worshipped at St Margaret's in Wolstanton or St James' in Newchapel.

A Catholic mission was formed at Plex Street in 1853 and dedicated to St Mary Immaculate; the building was also used as a schoolroom. On 21 December 1869 a new church (also dedicated to St Mary) with a presbytery attached was opened in Sun Street (now St Aiden's Street). The present familiar landmark of Sacred Heart was opened in 1930. In 1934, the old church and presbytery were sold for £1,600. The church became the main workshop of Taylor's Garage and Mr Taylor occupied the presbytery as his home.

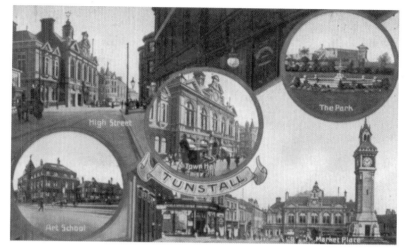

An early group of views of the town, *c.* 1905, showing Tunstall in all its glory.

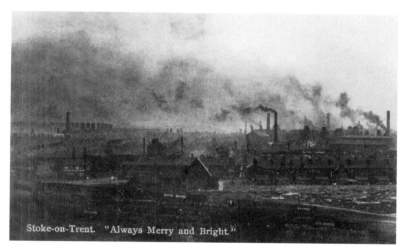

Somewhere in the centre of this picture can be found St Chad's church (demolished 2004), with the backs of terraced houses on King William Street to the right. The offending chimneys in the distance are in the Scotia Road/Pinnox Street/Williamson Street area.

Vast numbers of different comic cards were used throughout the country and localised by overprinting the name of a particular town or village, as seen here.

9

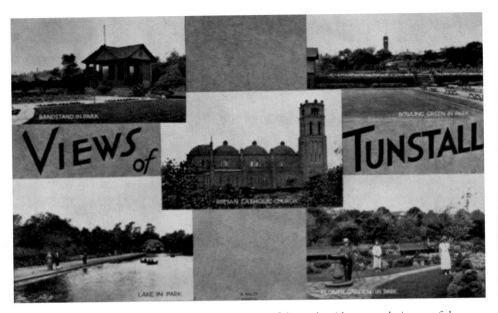

This relatively plain card is a mystery. The views are of the park with a central picture of the nearby Catholic church of Sacred Heart – it is more usual to see views of Anglican parish churches on town postcards. This card was produced by a firm in Middlesbrough, and the author has yet to see one of them postally used.

In 1882 the Salvation Army took over the dilapidated building on the corner of Sneyd Street (now Ladywell Road) and Victoria Street (now Harewood Street) which was originally known as the Prince of Wales Theatre, later known as the Theatre Royal and lastly as St James' Hall. In recent years the Salvation Army Corps has moved to new purpose-built premises in Dunning Street.

Each of the denominations and congregations could probably merit a book of their own but I will leave this for others to pursue. In this book, I make no apologies for merely scratching the surface and highlighting their prominent influence on the town.

The same applies to local industry. Back in the 1960s and '70s, Tunstall was in its heyday. At lunchtimes the streets of the town would swell with people from the nearby potbanks of W.H. Grindley, Enoch Wedgwood, H. & R. Johnson Tiles and Johnson Bros' Alexandra Works, as they did their shopping. These firms were major employers in the town and there were many other smaller firms in the side streets and further afield. Down in the Chatterley Valley was the Goldendale Ironworks, always visible from a distance by its 'eternal flame', and collieries surrounded the town. In those days it was not uncommon to see groups of colliers standing chatting, with rolled towels tucked under their arms, waiting for one of the pit buses to come and collect them and deliver them to their respective mines. Again, another valuable source of social history awaits an author.

In the meantime, sit back and enjoy this nostalgic trip back in time as we take a tour around the Tunstall you all know and love.

Don Henshall
2005

one

Tower
Square

Tower Square was originally known as Market Square. It remains a focal point for the town; the tower has stood on this site since 1893, proudly proclaiming the beneficence of Sir Smith Child.

The cost was £1,500, met wholly by public subscription. It is 50ft high and built of buff terracotta. There is a bronze bust of Sir Smith Child in a niche on the east side, facing the Town Hall. On the north side is an inscription which reads:

This Tower was erected by public subscription AD1893 in the town of his birth and in the 86th year of his age, in honour of Sir Smith Child Bart, a philanthropist, who, foremost in every good work, by generous gifts and wise council, sought to brighten the lives of the working classes, and by noble endowments to Convalescent Homes, offered a priceless boon to the suffering poor.

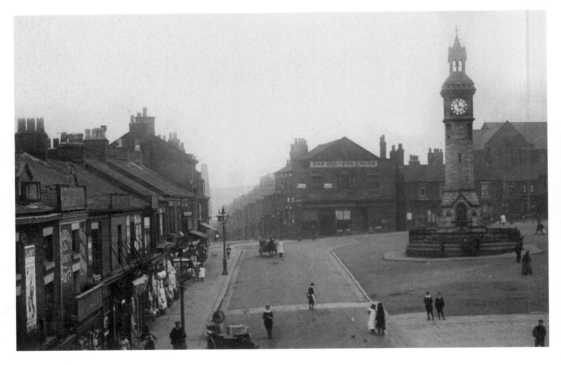

An early view of Market Square, c. 1910, looking west from High Street. Many of the buildings on the left and centre of this picture are still there today.

Opposite above: This view from around 1922 looks across the square towards High Street, with the Sneyd Arms Hotel to the right of the clock tower. Much of this north side of the square has been rebuilt over the years.

Opposite below: A busy day in around 1935. Buses and cars throng the square on what was possibly a market day. Note the two policemen keeping a watchful eye.

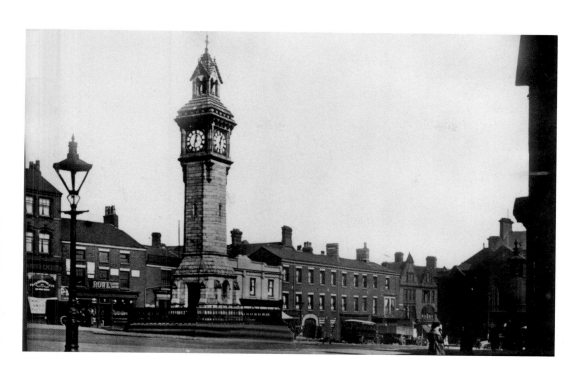

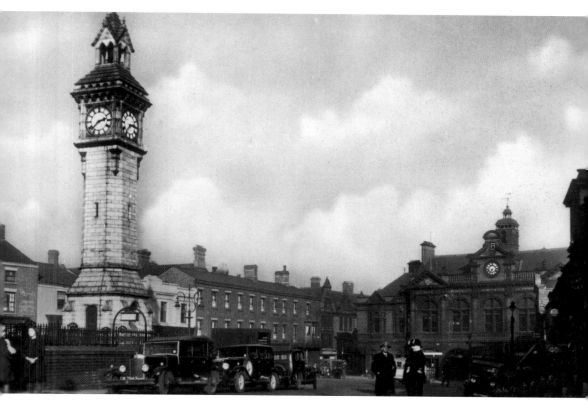

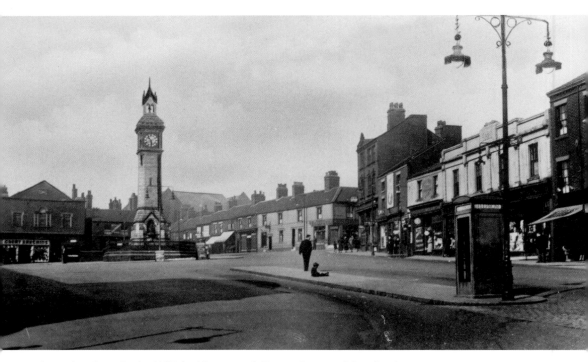

A much quieter day in 1937, looking towards Forster Street and Paradise Street.

Opposite above: Whilst the clock tower is unique in the city, it is not absolutely clear who was responsible for its design. What makes this more intriguing is the fact that there is an almost identical clock tower in Barnstaple in Devon. The towns are not twinned in any way and there appears to be no obvious connection between the towers.

Opposite below: On 22 and 23 April 1913 King George V and Queen Mary visited the Potteries. Flags flew and decorations adorned the public buildings as people throughout the towns awaited their King and Queen. Tunstall had the pleasure of their company on the final day and did them proud! Thousands of men, women and children thronged Market Square waiting for a glimpse of the royal couple as they made their way to the Alfred Meakin and H. & R. Johnson factories for an official visit. This was the first time the Potteries had been visited by a reigning sovereign and no-one was prepared to let the moment pass unnoticed.

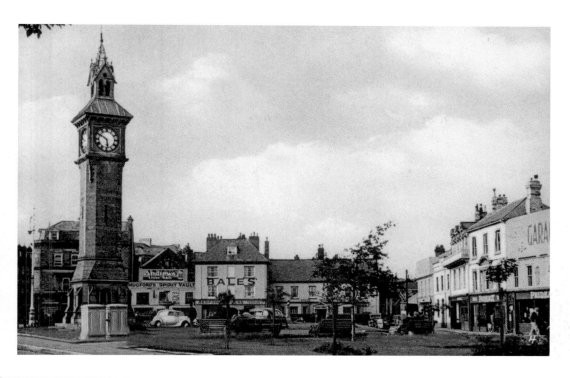

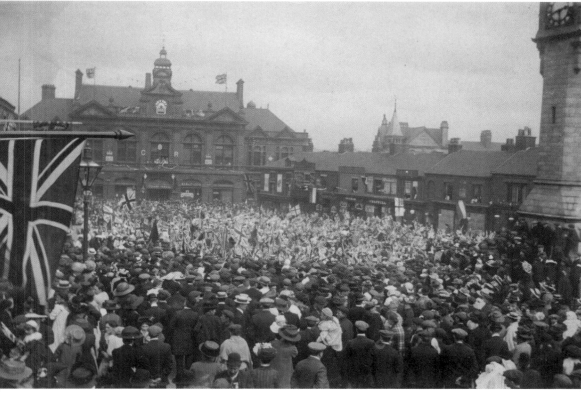

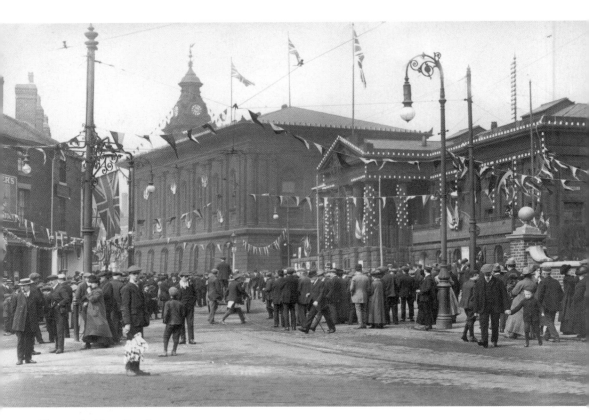

The royal visit to Burslem.

Opposite above: Crowds in Market Square, Hanley prepare for the visit of King George V and Queen Mary.

Opposite below: Local people were out in force in Stoke on 22 April 1913.

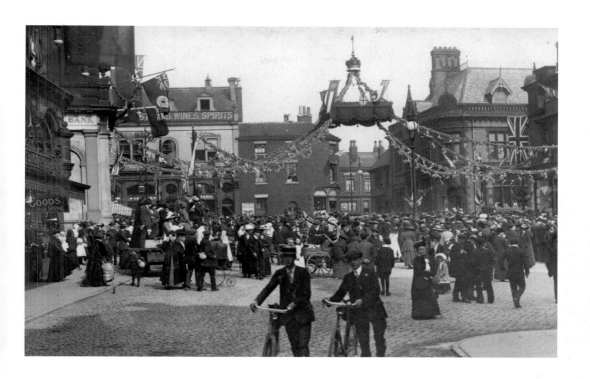

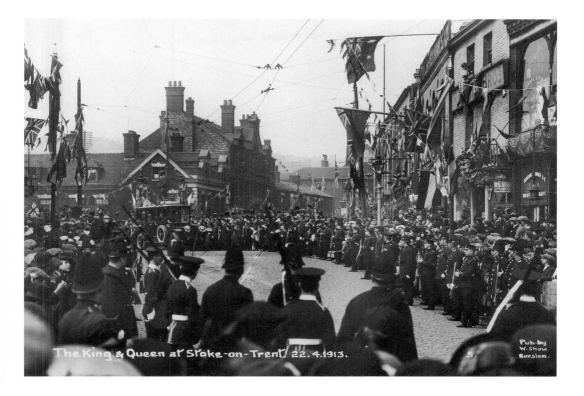

The King & Queen at Stoke-on-Trent. 22.4.1913.

Pub.by
W.Shaw
Burslem.

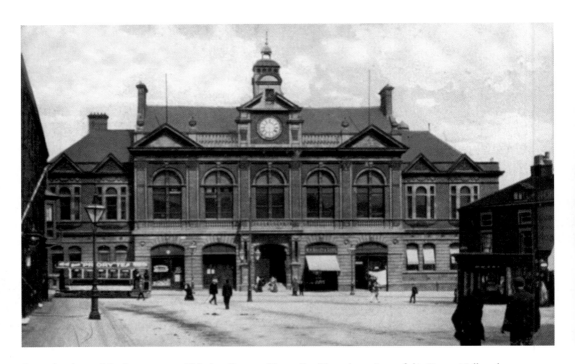

An early view of the lower part of Market Square, Tunstall with a clear view of the Town Hall and a passing tram.

two

The High Street

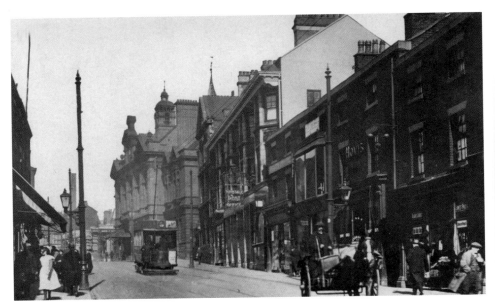

Above: This postcard shows the comings and goings of everyday town life. A man makes his way towards Burslem by horse and cart; someone jumps on the rear of the tram as it makes it way north through the town, and shoppers go about their daily business. In the distance, beyond the Town Hall, we can see scaffolding around a building on the corner of Station Road. This is now the local branch of the HSBC Bank, seen here under construction. A later card shows a stone on the building, recording its construction in 1886 though this date appears somewhat dubious as electric trams were not seen in the town until after 1898 and the Goldenhill route did not commence until 1900. It is likely this picture was taken around 1905. There is no trace of the earlier date-stone on the building today though it does bear a later date, AD 1920, which could refer to a subsequent refurbishment or alteration.

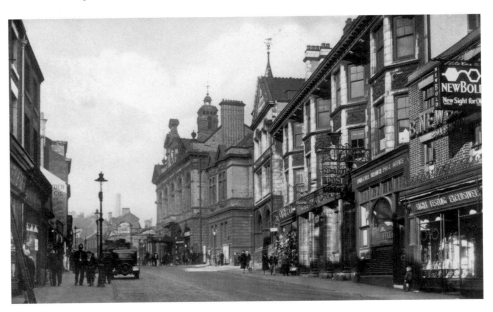

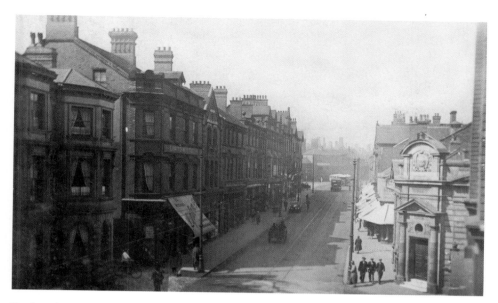

Further along High Street in a photograph taken from just outside the HSBC building, we get a view of Lipton's shop on the left. Two buses pass in the distance and a pony and trap trots along, heading out of town.

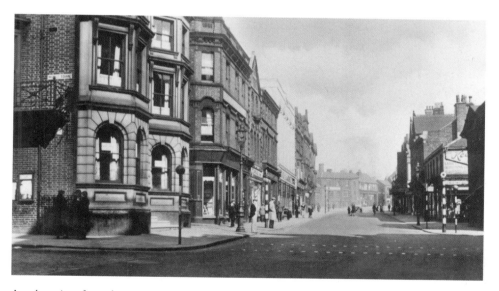

Another view from the same spot, but several years later in the 1930s. Lipton's have moved and the shop is now occupied by a paint and wallpaper business.

Opposite below: A similar view taken in the mid-1930s moves a bit closer to the Town Hall. The HSBC building can now be seen in all its glory. To the right of the picture there is a wonderful cast-iron sign (almost certainly made by William Durose) hanging outside the post office. Whilst the post office is still there today, the sign has long since disappeared. Thankfully, a similar one still exists on the side of the Victoria Institute/library in Greengate Street.

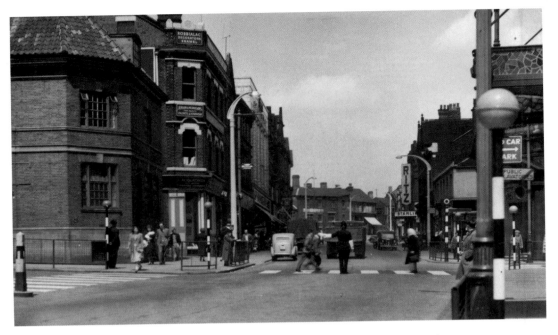

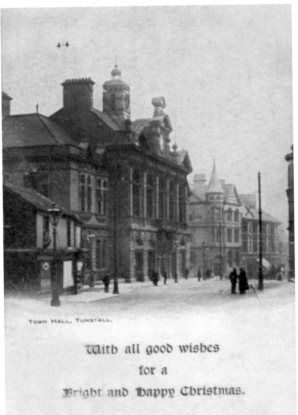

TOWN HALL, TUNSTALL.

With all good wishes
for a
Bright and happy Christmas.

Above: This 1950s view shows more traffic now coming into town and the obvious need for a policeman to be on point duty. The Sneyd Arms Hotel had a totally different look following major building works.

Left: The view on this card must predate the building of the HSBC branch since there is no sign of the previous business premises having been vacated or demolished. This appears to date the negative to around 1900 and, whilst the design of the card indicates it to be one in use prior to 1902, it was actually posted on 24 December 1903. Obviously postcard sellers kept their stock for some time or particular views were so popular that they remained in print for several years. In this era there would have been collections and deliveries of post on Christmas Day so this over-printed card would have just made it in time for the festivities.

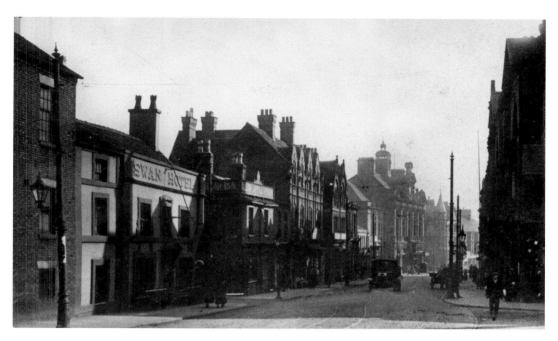

The Swan Hotel was an old posting house. It joined onto the Swan Pottery where the roundabout is situated at the top of High Street. At the rear of The Swan, in Hunt Street, was a brewery.

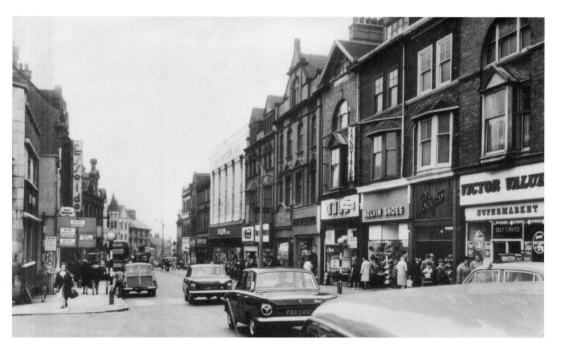

A more modern view, taken in the 1960s, shows that while businesses may have changed hands and frontages have been altered, the buildings in the area have remained much the same for the past eighty years or so.

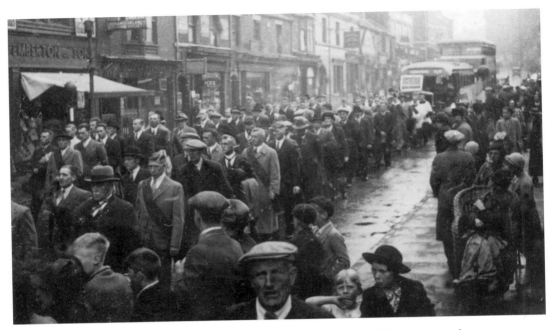

Here is a view of High Street grinding to a halt as a procession takes place. This was not to do with trade unions or poll tax, it was a Catholic procession. On many holy days over the years the congregation would walk from Sacred Heart church on Queens Avenue through the town, often led by Father Ryan and his acolytes. This particular procession took place in the late 1930s, although it's not clear what the actual event was.

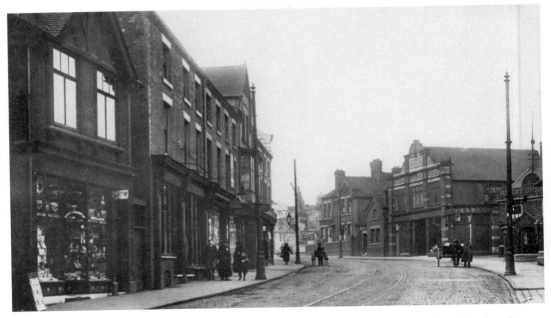

This view shows the upper part of High Street as it leaves the town heading towards Christ Church and beyond. The ancient Wheatsheaf public house is on the extreme right of the picture.

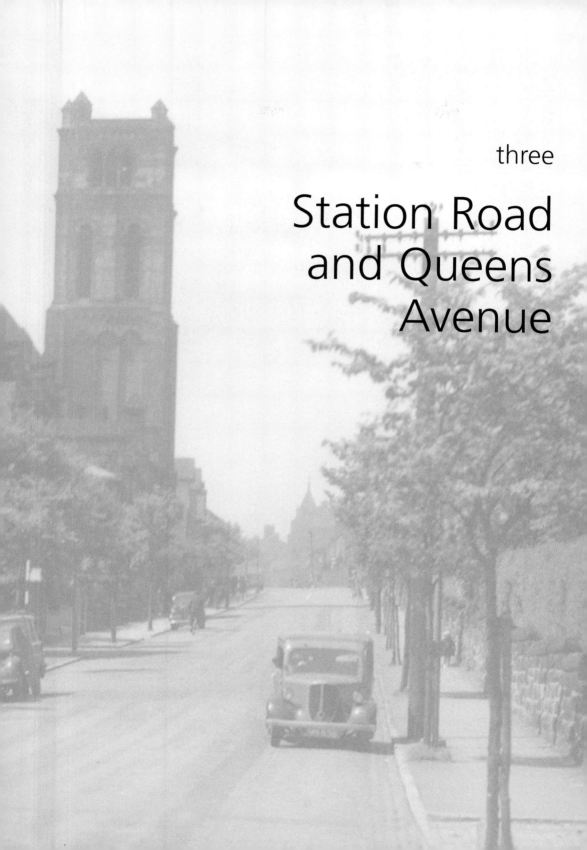

three

Station Road and Queens Avenue

For obvious reasons, Station Road (later The Boulevard) has always been a busy thoroughfare. The road is at right angles to High Street at the bottom of Market (Tower) Square and travels along the side of the Town Hall building heading towards the Memorial Gardens, Tunstall Station, Victoria Park and Queens Avenue. Today the architecture of the area is little changed and is still recognisable from old pictures and postcards.

However, one major occurrence which did have a dramatic effect on the area involved the road being dissected to enable Scotia Road (A50) to be extended and, in effect, become a mini bypass. Prior to this event, traffic on its way north would join High Street via Pinnox Street and travel through the centre of town. Increased traffic in the 1950s and '60s could not be allowed to keep blocking the town centre and it made economic sense at that time to build the new road; today's traveller is probably totally unaware that the road was ever any different. The downside to this reconstruction was that the Jubilee Buildings, housing the public library, Victoria Institute and the swimming baths, were left stranded across a very busy road, although an underpass was built for pedestrians and is still much used today.

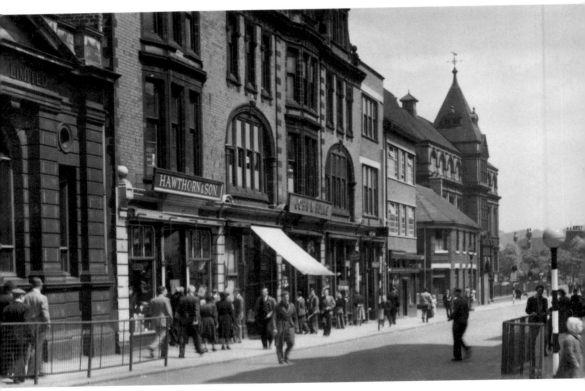

This postcard from the mid-1950s shows how busy Station Road was. Beyond the shops, on the corner is the Sentinel Building, which was a sub-office for the local daily newspaper. Across the junction on the opposite corner is the Station Inn, which was to be a casualty of the Scotia Road extension, and the building in the distance (with the pointed roof) is the Jubilee Buildings, built in 1889/90 to commemorate Queen Victoria's Golden Jubilee.

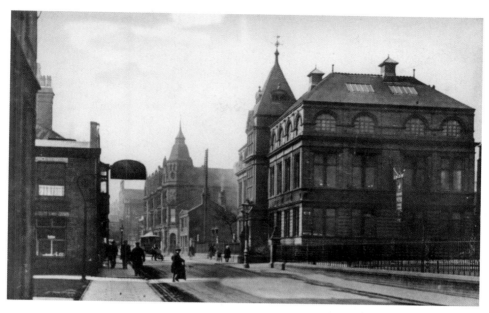

In this view looking west along Station Road, we can see on the right the railings of the newly laid-out Memorial Gardens. On the side of the Jubilee Buildings can be seen the impressive metal sign for the public library, which was housed in the building in August 1891. The sign was made by William Durose in 1901 and is a wonderful example of the craftsman's art. His business began in 1880 and was a regular gold- and silver-medal winner in local competitions. A similar sign hung outside the post office on High Street in the earlier part of the nineteenth century but has long since disappeared. Durose's most famous commission was the manufacture of the park gates. On the left-hand side of this picture is a billiards hall.

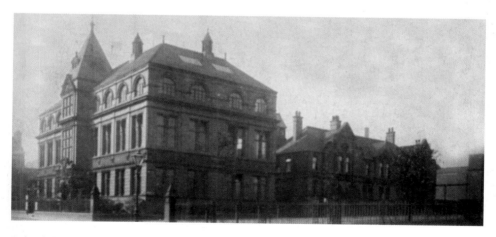

Behind the main Victoria Institute and part of the Jubilee Buildings were the public swimming baths and the fire station. Opened on 28 July 1890, the swimming pool measured 72ft by 28ft. There were also eight private baths and Turkish and vapour baths. When the old Town Hall was built in 1816 it housed two fire engines. The Tunstall Board of Health later assumed responsibility for them and opened a new fire station in the Jubilee Buildings. This station closed in 1926 when the Burslem brigade took over the Tunstall area.

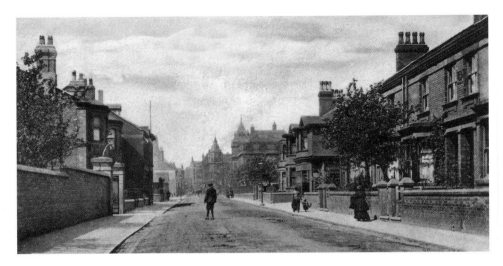

This postcard was locally produced by the printing firm of Edwin H. Eardley, which was prolific in the production of postcards showing views of the local area and other printed matter. The card is postmarked 1905 but the view is believed to be earlier than this. In the foreground on the left can be seen a wall leading to an arched entrance to Tunstall Station. In the distance in the centre of the view can be seen the Jubilee Buildings, with the Sentinel Building beyond.

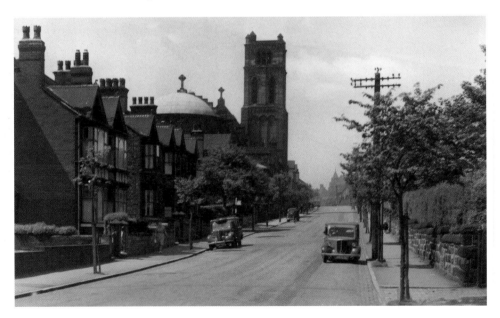

Travelling further along Station Road (The Boulevard), the road passes the junction with King William Street and Victoria Park Road and becomes Queens Avenue. Apart from the lack of traffic this view is exactly the same today. The houses on the left were built around 1910 and in the centre is the Sacred Heart Catholic church. This was opened in 1930 and replaced the previous Catholic church in Sun Street (now St Aiden's Street). The church is very large and, with its green copper-covered domes, is a distinctive landmark visible for miles around. The church was built by Father Ryan.

four

The Park and Memorial Gardens

Victoria Park covers thirty-two acres and was laid out between 1897 and 1908. It contains a large lake, recreation grounds, bandstands and tennis and bowling greens. There is a clock tower erected to the memory of William Adams (1745-1805) and his grandson William Adams (1833-1905), both eminent Staffordshire potters, with bronze portraits of each fixed to the tower.

The land was known to be a field of coal pits and refuse heaps, so much work was required to bring beauty to the new venture. This succeeded and this famous park incorporated many unique features, none more so than the gates to the main entrance on Victoria Park Road. The Peake family were well known in Tunstall. Thomas Peake (1798-1881) was a tile manufacturer in the town who in the late 1820s was producing all manner of bricks, tiles, pipes and ornamental garden pottery at his factory in Watergate Street. He was a contributor to Christ Church in 1831/32 and held prominent positions in the town, including chief bailiff, a post he held three times. Upon his death he was succeeded in his business by his son, John Nash Peake (1837-1905). The Peake family, notably John Nash Peake, commissioned William Durose, the art metal worker, to construct the park gates at their expense in memory of their late father, Thomas. The three gates bear the inscription FLOREAT – IN MEMORY OF THOMAS PEAKE BY HIS CHILDREN, AD1904 – TUNESTAL.

Part of the land acquired for the park was used to construct a new road to the west. This was initially known as Victoria Road, but today it is Victoria Park Road. Smart houses were built on the road with magnificent views of the park.

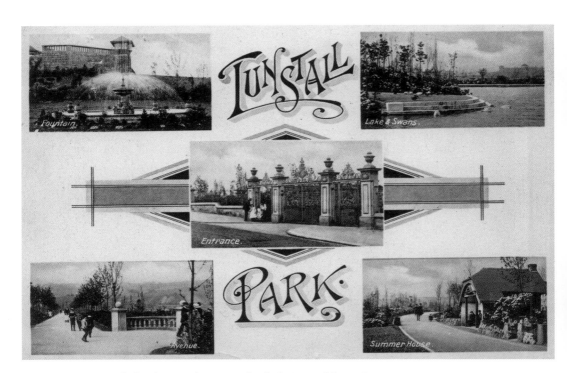

A multiview postcard, dated 1908, showing individual views of the park.

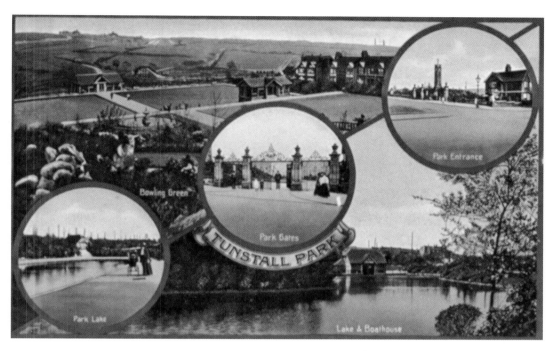

Another multiview card, dated 1911, showing prominent views of the lake and bowling greens.

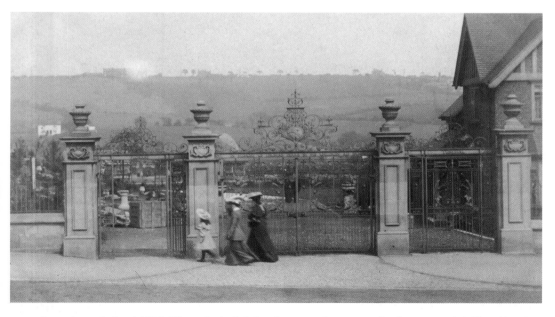

An early card, dated 1905. Through the left-hand gate can be seen a wheelbarrow on its side with a packing case. Beyond these, on the garden, are several urns and pots being laid out in the area which was to be at the foot of the Adams clock tower. In the distance there are open fields rising up to High Lane. Today this is the area known as Mill Hill and is a densely populated housing estate.

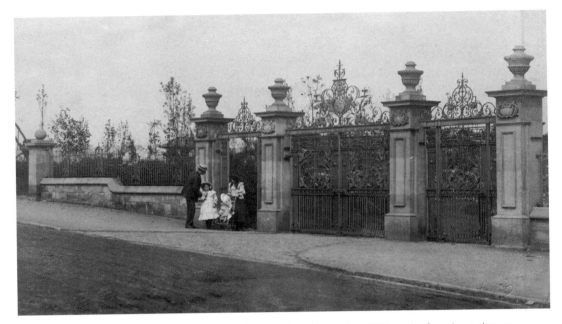

A family makes their way home after a trip to the park. Postally used in 1907, again there is no sign yet of the clock tower!

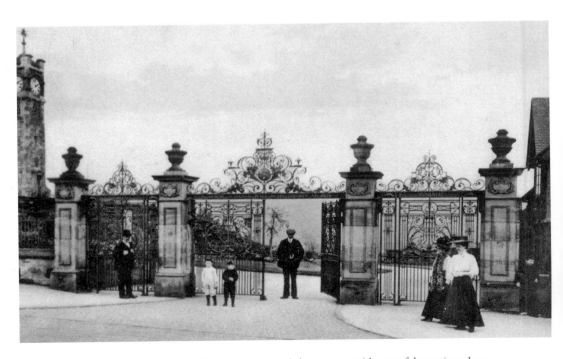

By 1910 the clock tower stands proudly to attention and the gates provide a useful meeting place.

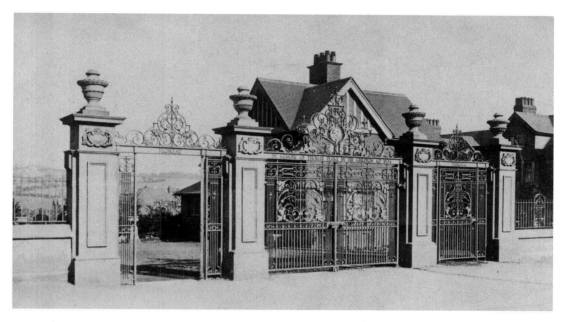

This view, published by Eardley's, shows the gates in their magnificence with the park-keeper's lodge in the background. Today this is a children's nursery.

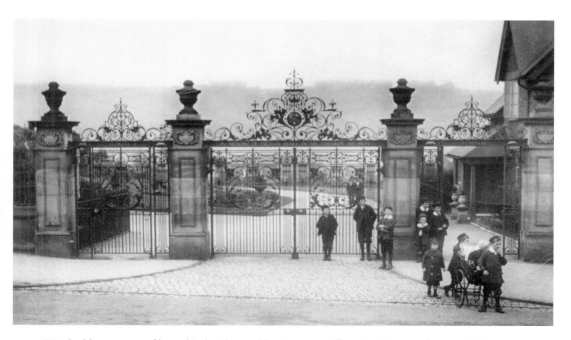

Watched by a group of boys, big brother and his sisters set off on their journey home with the youngest one perched in a grand high pram.

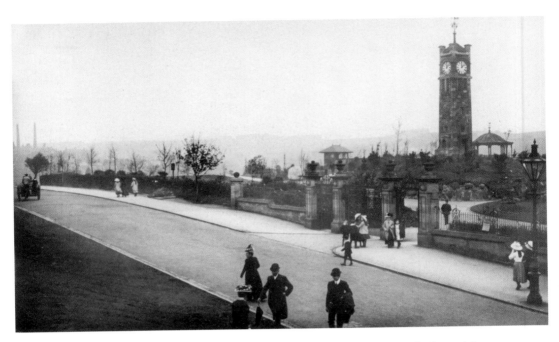

The park was a popular place with families by 1910 and attracted a steady stream of visitors. A horse-drawn cart disappears out of view making its way to Pittshill and Chell, while others make their journey on foot.

A view from inside the park with the park-keeper's lodge to the left and the station-master's house in the middle distance.

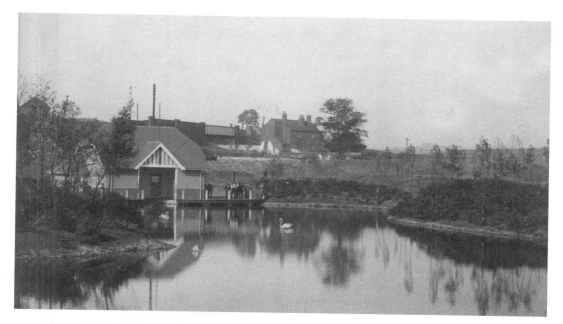

The park is beginning to take shape in this scene and two swans have already taken up residence. In front of them, in the shadow of the boathouse, can be seen a child's model yacht heading for the shore. In the middle distance is the old railway bridge, close to Pittshill Station. On the reverse of this postcard the message reads 'The park is not finished yet, but I think when you come next summer you can have a row on the Lake, a Bowl on the green or a game of Tennis or even a roll down the Bank'.

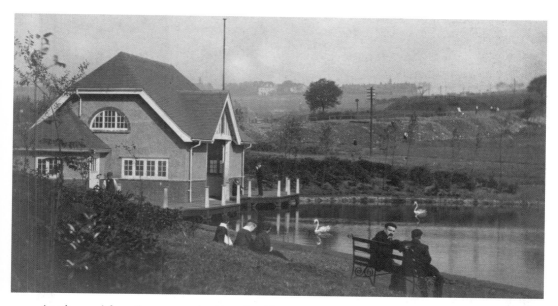

Another card from the same sender (though with no message) shows clearly the work being undertaken to lay out the grounds. Whilst the boathouse, landing-stages and lake appear finished, there is much activity in the distance, alongside Little Chell Lane, to form banking out of the rubbish heaps which were inherited with the land.

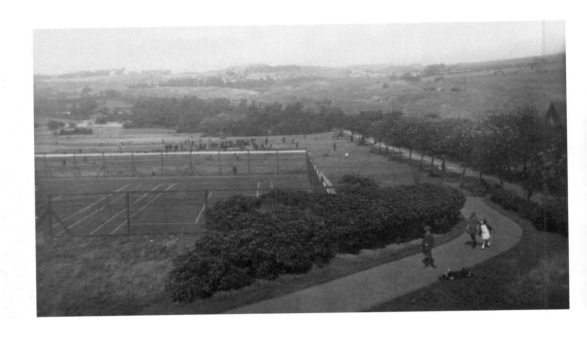

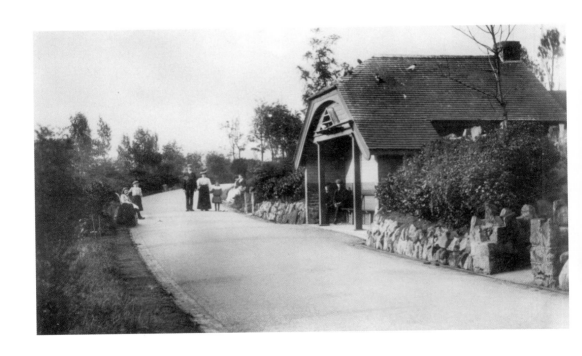

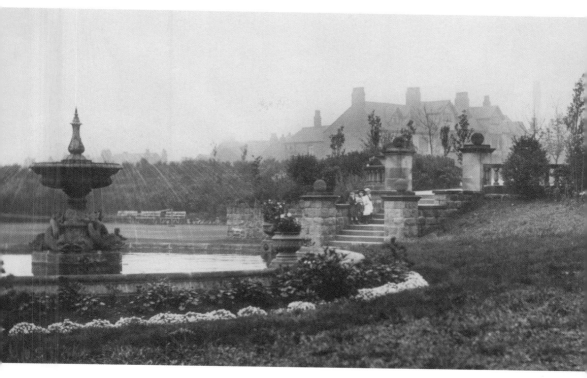

Another striking feature of the park is its fountain and lily pond. A plate on the front states that 'This fountain was presented to the town in memory of George Cumberlidge, JP, by his children'. To have seen it in full flow must have been quite a spectacle. The open space in the distance beyond the fountain was later occupied by Sacred Heart church.

Opposite above: Here the newly laid-out tennis courts can be seen. In the centre of the picture, on the recreation ground, there is a large gathering of people. They appear to be watching a football match in progress, though the 'players' appear to be in their normal everyday clothes.

Opposite below: Proud parents stand and pose with their daughter for a photograph outside the 'Pigeon House'. This and other similar buildings were strategically placed throughout the park to provide temporary shelter from inclement weather. This particular postcard left Tunstall at 8.15 p.m. on 28 December 1910 for Brooklyn in New York where, its postmark confirms, it arrived at 8.30 a.m. on 5 January 1911. That speed of delivery would be hard to match today even with fast jets and computer technology. Somehow or other the card has found its way back to Tunstall to tell its tale today.

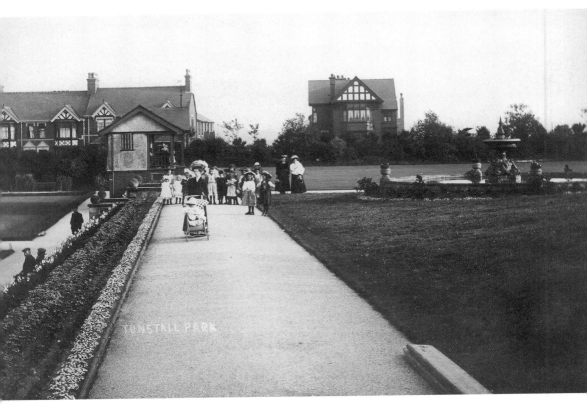

TUNSTALL PARK

This photograph, taken in 1909, has the bowling greens on the lower level to the left and the fountain to the right. The detached house in the middle of the picture is situated on the corner of Queens Avenue and May Avenue and was built in 1904/05 by William Colton Moulds, who was a saddler on High Street. His father, who lived in Stanley Street, had a saddlery in Newcastle Street, Burslem. W.C. Moulds was a prominent member of the Wesley Place Sunday school and was its superintendent from 1887 to 1905 and secretary in 1870/71. He lived at 'Lingodell' until 1921 when the house was sold to Mr Richard W. Hayden, who had a retail clothes shop in Tunstall. Over the ensuing decades the Hayden's shops became familiar and important sites on the high streets of most, if not all, of the towns in the Potteries and Newcastle.

It's not clear who the family are in the picture, but the text on the card reads 'Dear Mother, arrived at Alice's safe but there was a heavy rainstorm just as we got off the train and it did not clear up till after teatime but it is nice today. Yours Jack. P.S. This is Alice with the carriage'. There is a further added comment which states 'Found this on P.C. stand. We roared when we saw what it was. Alice and baby going on very well. Hope Ethel got home safe'.

The house on the opposite corner was the home of William Johnson and his family. Mr Johnson came to the area to take on the position of head of the School of Art in Burslem. His son Paul Johnson, the celebrated historian and author, published a book in October 2004 entitled *The Vanished Landscape: A 1930s Childhood in the Potteries*. This describes a near-idyllic period in his life as a young boy, living in Tunstall during the Depression. One of the anecdotes in the book recalls a visit from the artist L.S. Lowry, who was a personal friend of his father.

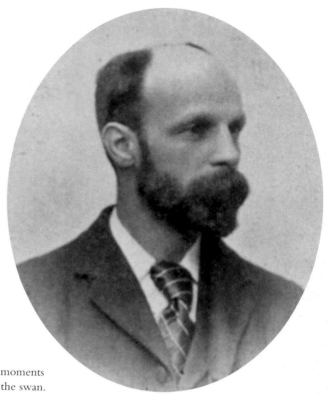

Right: W.C. Moulds.

Below: A family spends a few tranquil moments by the lake in 1909 and mother feeds the swan.

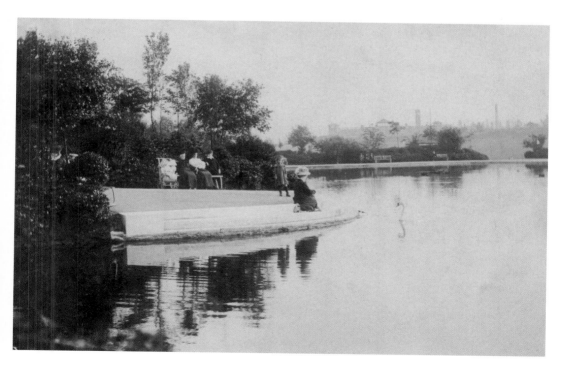

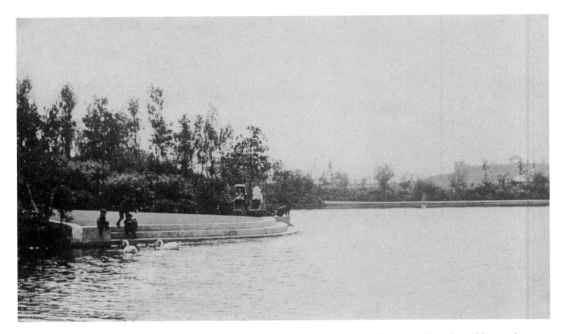

Three lads are busy feeding the swans. Two bath chairs/carriages are parked on the lakeside and beyond, in the middle of the picture, is a man on all fours, peering into the lake. Has he dropped something or is he looking for tomorrow night's tea?

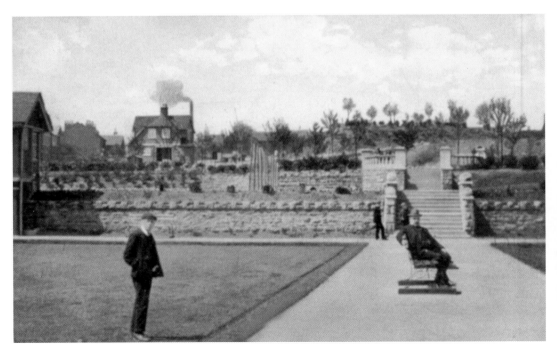

A 1907 view of the bowling greens with the Lodge in the background. We can see that the mound has been formed on which the clock tower was to be erected.

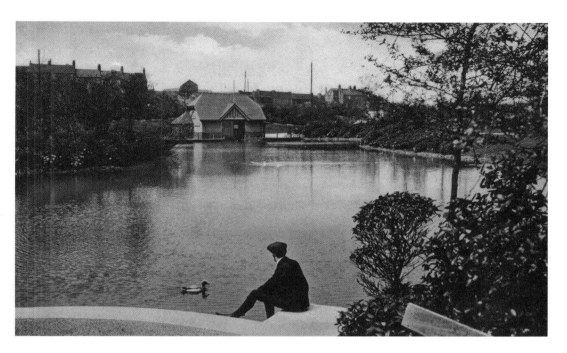

A man enjoys a quiet time by the lake with only a solitary duck for company.

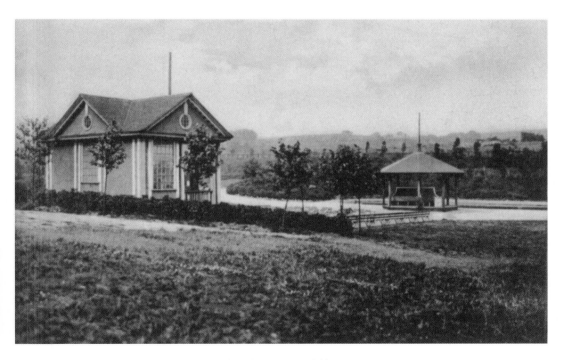

The bandstand, with open-air and sheltered seating available.

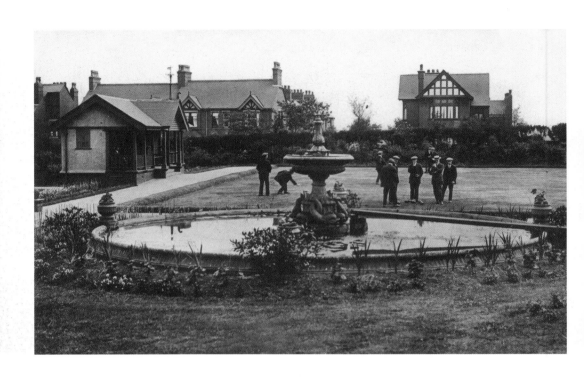

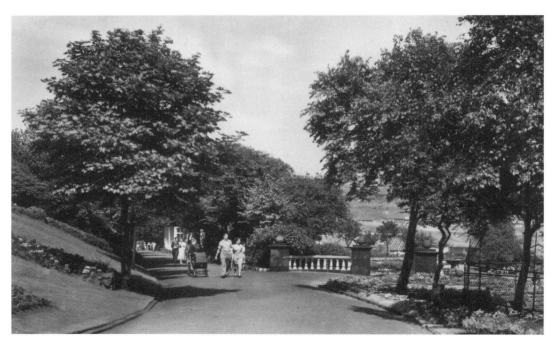

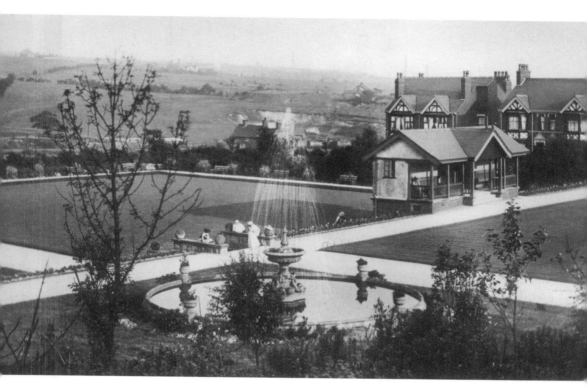

A view across the bowling green makes a peaceful scene. The houses in Queens Avenue marked the end of the road at this time. A track led into Greenbank Road on the journey towards High Lane. It would be some years before these were linked into a continuous road as they are today. In the distance there is a farm and a few cottages dotted about. Out of view there is a goods and mineral railway line that ran across the lane to Chatterley Whitfield Colliery. By 1930 the present tunnel and bridge had been constructed.

Opposite above: Another (later) view of the fountain, with Queens Avenue beyond. Men are bowling on this upper level, which has also been used as a croquet lawn.

Opposite below: A summer's day in the park. Many a baby must have had their first outing in this park.

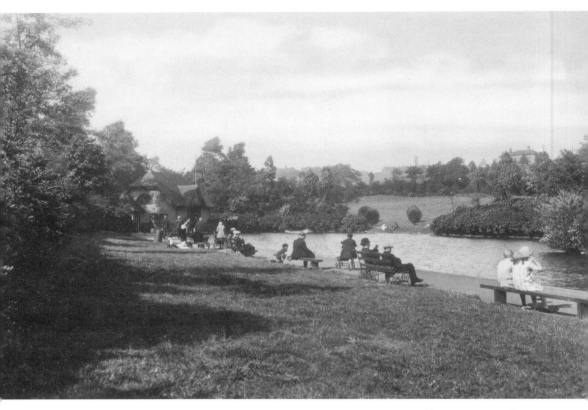

Back at the lake, people sit around making the most of the fresh air. A couple of boats are moored on the far side.

Opposite above: Here are the intrepid sailors. This must have been quite a novelty in its day. There was not much scope for 'messing about on the river', as the River Trent is in its infancy in the Potteries; the canal would be full of its own craft and barges carrying wares and materials to and from the pot banks, and the nearest seaside is some seventy miles away!

Opposite below: Another locally published card, this time by T.H. Pemberton. The card is dated 1912 and is sent from Alice (see page 38) to her aunt and uncle. In it she refers to Ethel living in Middleport and to Tom going off 'photographing'. Was he the one responsible for the wonderful memories immortalised on these postcards?

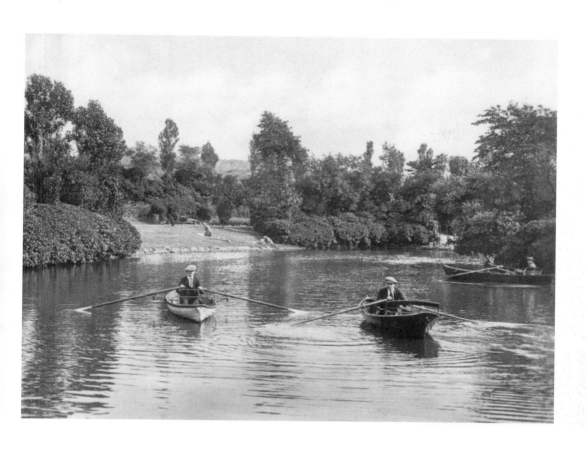

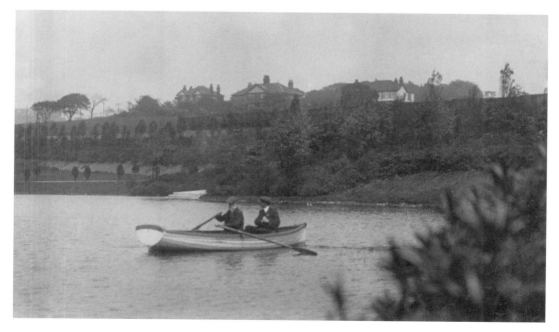

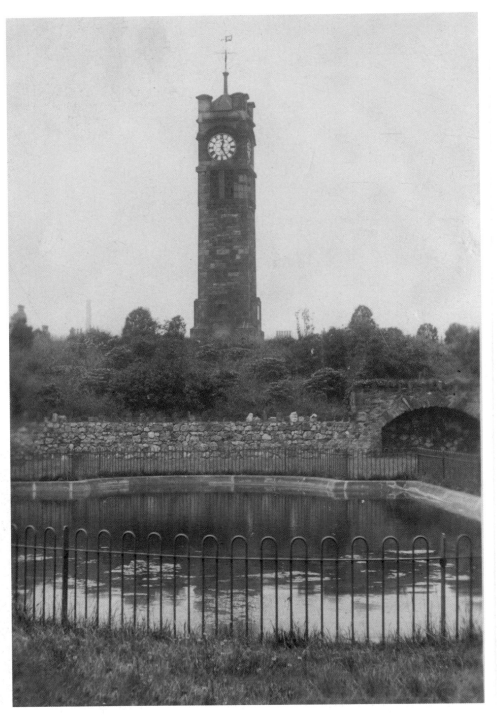

The clock tower proudly stands guard over the paddling pool. This was a very popular place with local children in the summer months. Several years later it was turned into a very attractive heather garden.

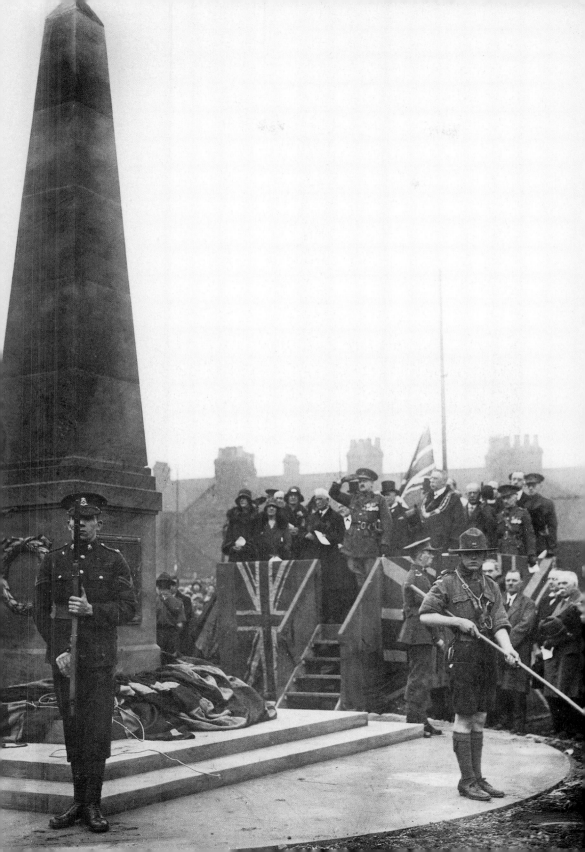

Previous page: Next to the Jubilee Buildings are the Memorial Gardens. We can see from early pictures that the grounds were laid out and railings erected in the late 1890s and early 1900s as a recreation area.

An obelisk forms the central focal point of the gardens and bears plaques commemorating the fallen soldiers of both world wars. For several years, on Remembrance Sunday, representatives of the British Legion, the Salvation Army band, local Scout and Guide packs and Army Cadets have joined with members of local churches and townspeople to honour the dead and lay traditional poppy wreaths.

In the 1990s, members and ex-members of Tunstall Rotary Club organised a major fundraising effort to restore the clock tower in the square to its former glory, and they were successful in achieving their goal. Now, on 11 November each year, a separate remembrance service takes place in the square at the foot of the tower, which is attended by civic leaders, veterans of past conflicts, local schoolchildren, representatives from commerce and industry in the town and members of the Chamber of Trade. Numbers have continued to grow each year and it is now a recognised part of life in Tunstall's social calendar. In this photograph a group of local dignitaries, representatives of the armed services and Scout groups look on at the solemn moment when the fallen are remembered and honoured.

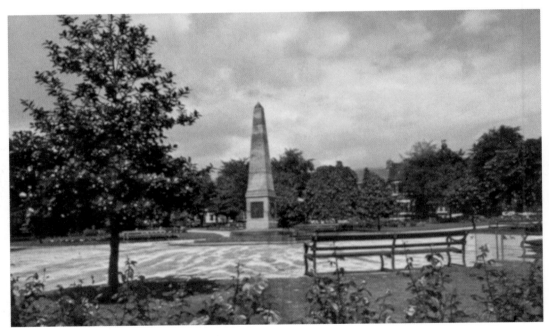

A peaceful scene in the gardens on a summer's day with the roses in bloom.

five

Industry, Commerce and Transport

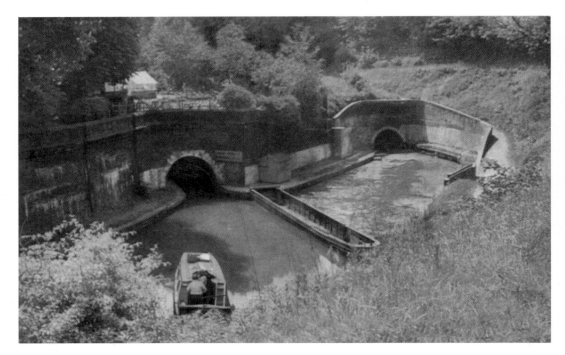

James Brindley (1716-1772) was a celebrated canal engineer whose work in the Potteries helped create the rapid rise of the ceramics industry. This particular canal was only one of Brindley's many ventures and the creation of the Harecastle Tunnel was a truly magnificent feat in itself. Unfortunately, Brindley died halfway through its construction and it was completed in 1777 by his brother-in-law Hugh Henshall. The tunnel was 2,880 yards long and 190ft below the summit of the hill it passed through. Brindley did not construct a footpath, so men had to lie on the tops of their boats and 'walk' the boat through against the tunnel walls. It took two hours to 'leg' through and, as there was no room for boats to pass, huge queues would form at either end. Horses had to be unhitched and walked over the hill to meet the barges at the other end.

Thomas Telford (1757-1834) was employed to draw up plans for a new tunnel with a towpath and through sheer hard work this was achieved within three years, opening in 1827. Unfortunately, Brindley's tunnel fell into disrepair and was eventually closed. In later years, Telford's towpath was closed also but his tunnel is still used by today's canal craft.

Opposite above: Boats moored up waiting to pass through the tunnel.

Opposite below: A deserted Tunstall Station, *c.* 1964. The North Staffordshire Railway Co. was formed in 1846. A loop-line linking all of the Potteries towns was built and became known as 'the Knotty' because of its use of the Staffordshire Knot emblem in its livery symbol.

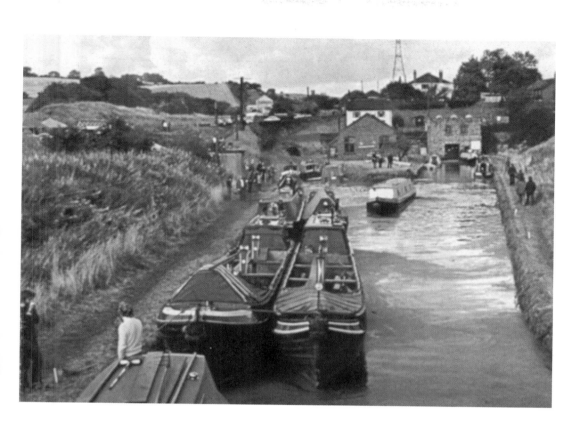

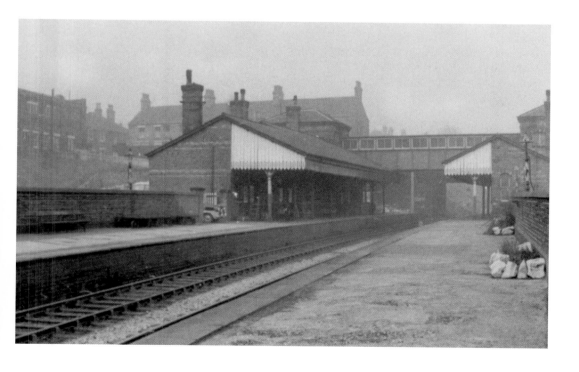

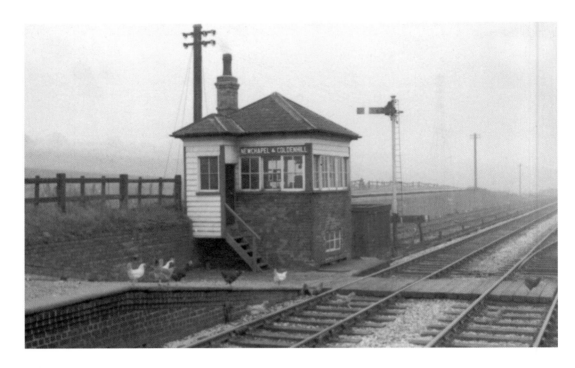

Above: Free-range chickens have the run of Newchapel and Goldenhill station.

Below: A goods train has a temporary stop at Pinnox Junction.

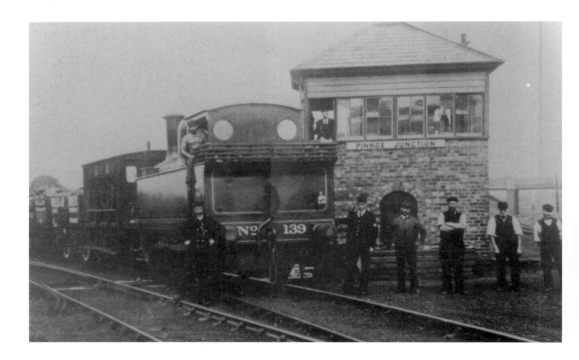

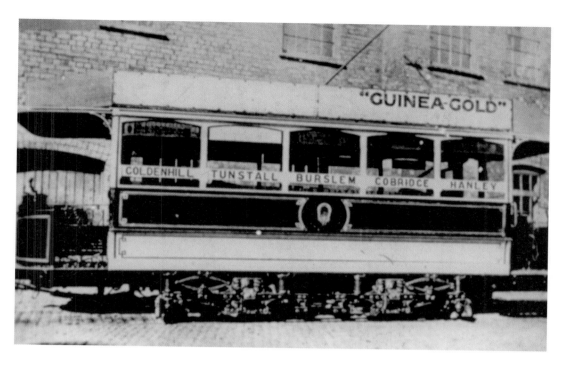

"GUINEA GOLD"

GOLDENHILL TUNSTALL BURSLEM COBRIDGE HANLEY

Above: One of the Potteries Electric Tramways cars ready to call at Tunstall, *c.* 1910.

Right: This bus belonged to Brown's Motors (Tunstall) Ltd and was in service in around 1931. By 1951 Brown's was the largest independent operator in the Potteries.

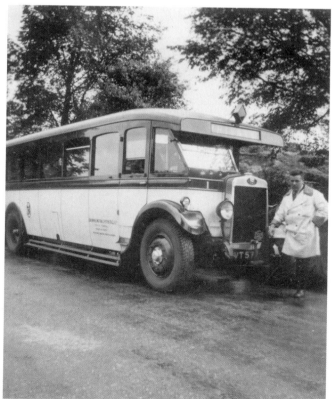

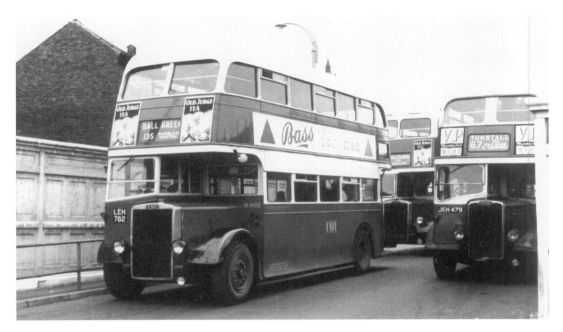

This double-decker bus heading for Tunstall first saw service with PMT (Potteries Motor Traction Co.) in 1943.

A delivery van in around 1930. These were becoming familiar sights on the streets of Tunstall at this time.

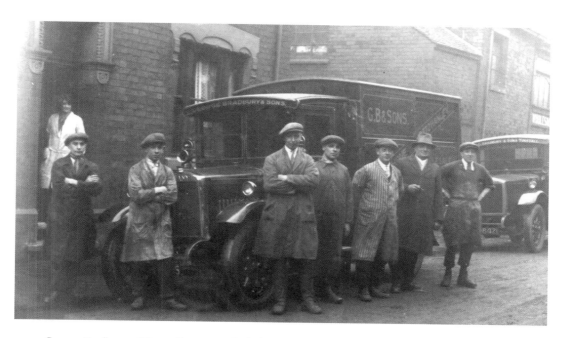

George Bradbury of Tunstall was a cattle dealer and butcher operating from 115 High Street in 1896. By 1921 the business had expanded and was known then as George Bradbury & Sons, wholesale meat salesmen, and was operating from 6 Keele Street. They were still operating from this address in 1928.

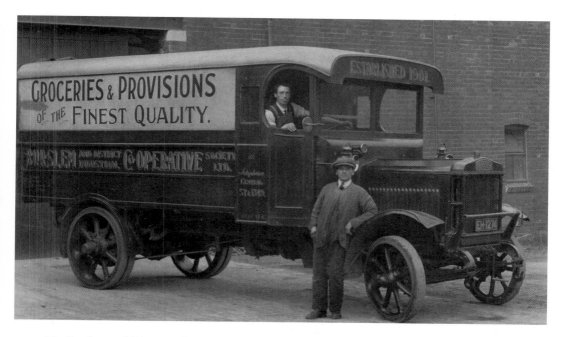

The Burslem and District Industrial Co-operative Society was established in 1901. By 1921, several grocery branches were opened in and around Tunstall and a large store was opened in Market Square. Deliveries of larger items, including furniture, were 'brought to your door' by the Co-op's fleet of vans.

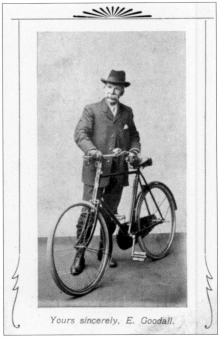

Yours sincerely, E. Goodall.

Above: Mr E. Goodall poses here with one of his 1910 model bicycles. His shop on High Street offered all kinds of new cycles and 'a few good second-hand machines' too.

Left: This bookmark was presented by Edwin H. Eardley, printers. All kinds of stationery was provided in their shop in Market Square and they produced their own postcards for sale too, prior to the First World War.

Opposite: To enable wares to be stacked high in the bottle-shaped ovens of the potbanks they were put into containers called 'saggars'.

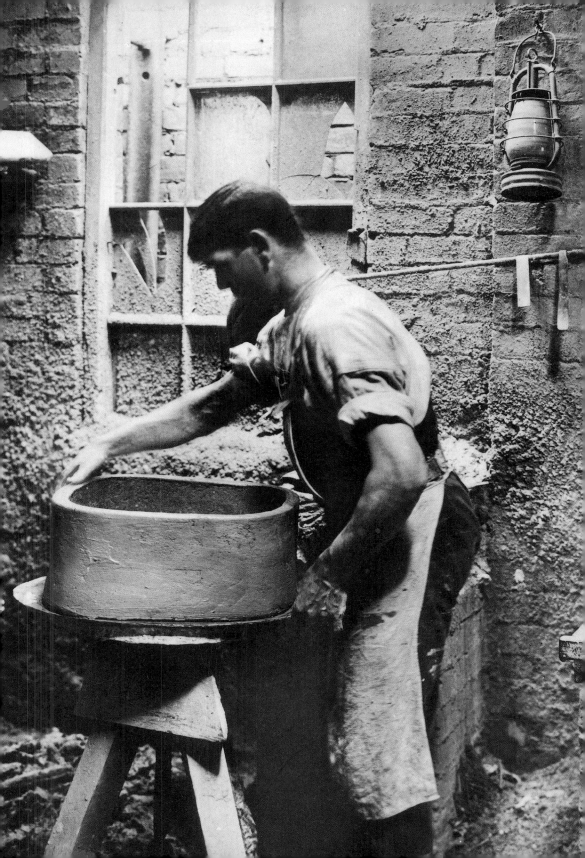

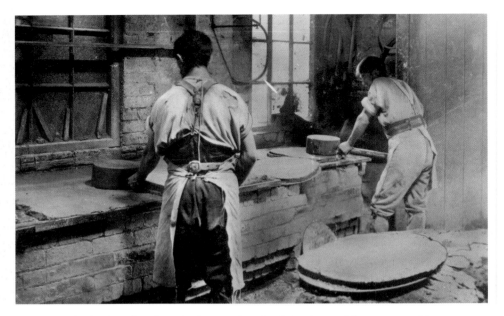

The saggars had to be of uniform thickness, otherwise firing times of the wares would vary and they could be damaged in the process. The walls of the saggar and its base would be made separately and then stuck together to form the container. The correct thickness would be ensured by hammering the clay flat inside a metal frame with a large wooden mallet. The man who made the bases was known as the 'saggar maker's bottom knocker'!

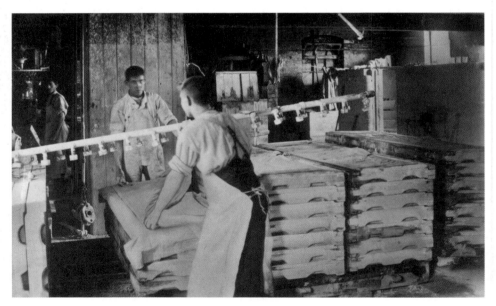

In the sliphouse, large cakes of clay would be formed by pumping liquid clay (known as 'slip') through a large filter press and squeezing the machine together to remove all liquid. The resulting slabs of clay would be supplied to the 'maker', who would then use his skill to turn the material into the required product.

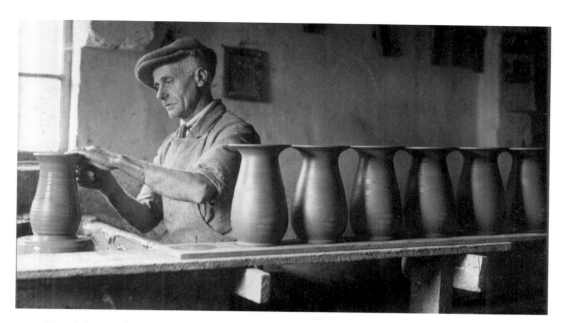

Vases being produced on a potter's wheel by 'turning'. The potter's skill enabled him to produce many articles of a uniform size and shape without a mould.

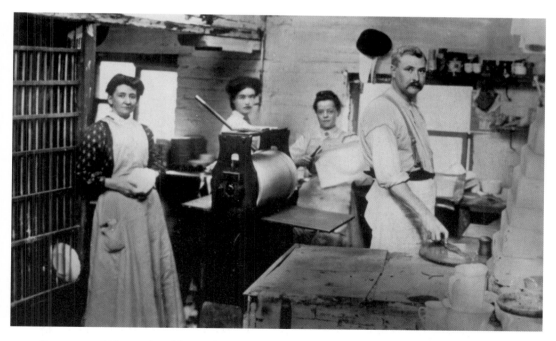

Patterns would be produced by a printer. Designs for the pattern would be etched onto a copper plate and then mounted on a drum. Ink was applied and tissue paper fed over the revolving drum (like using a mangle) and the pattern would be transferred onto the paper. The paper holding the pattern would be applied to the article to be decorated and then removed. The pattern stays on the ware, which is then fired at a high temperature to 'seal' it onto the article.

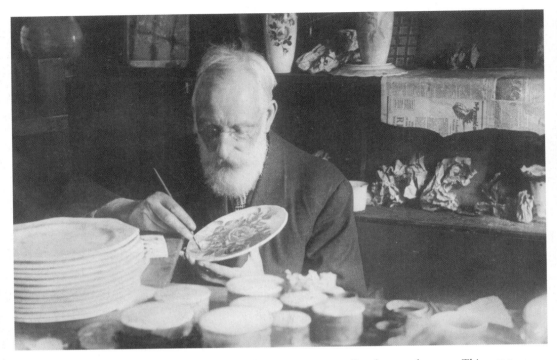

The alternative method of decoration is to paint the pattern or scene directly onto the ware. This was a highly skilled artistic job.

Opposite: Lipton's shop at 91 High Street. The window arrangement looks inviting and the range of goods on offer (several of them 'own brands') are given full prominence. The staff look proud to be photographed with their display.

LIPTON

LIPTON'S
FAMOUS SAUSAGES
BEEF 6
OXFORD 8
CAMBRIDGE 1.
FRESH DELIVERIES DAILY

LIPTON'S
EMPIRE
BUTTER 2/1

THE BENEFITS
of
LIPTON'S
XMAS CLUB
ARE MANY
WHY NOT BECOME A MEMBER
TO-DAY?

LIPTON'S
THE FAMOUS
YELLOW LABELS
PER **2/8** LB.
THE BEST TEA IN THE WORLD

EMPIRE GROWN
FRUIT
CURRANTS 4
RAISINS 4
SULTANAS 10

FINEST OBTAINABLE
SELF RAISING
FLOUR
3 lb BAG **8**

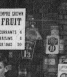

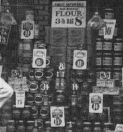

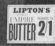

PRICE
REDUCED

LIPTON
Finest Quality
HOUSEHOLD
FLOUR
Reduced to
PER
2/3

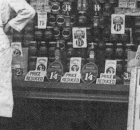

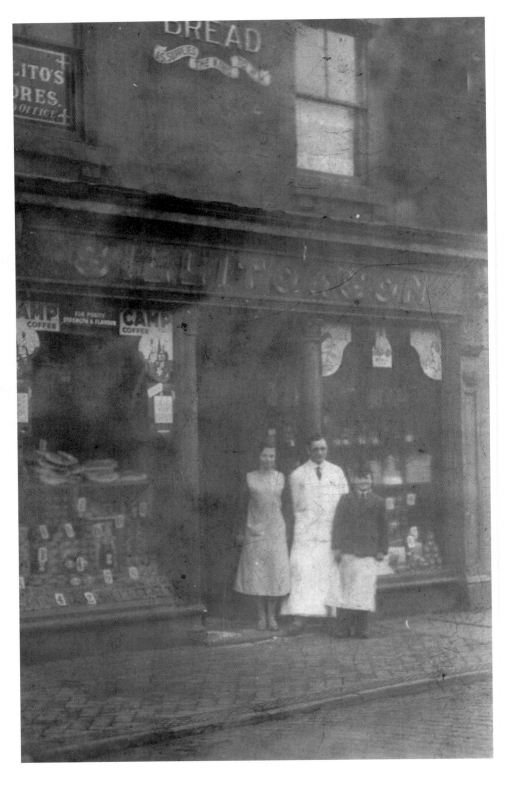

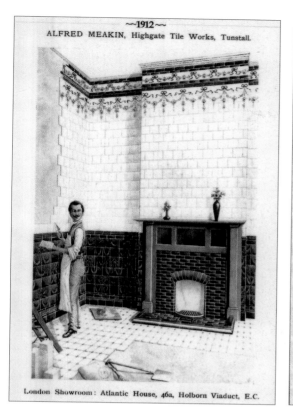

~1912~
ALFRED MEAKIN, Highgate Tile Works, Tunstall.

London Showroom: Atlantic House, 46a, Holborn Viaduct, E.C.

This page and following: Advertisements for various businesses and products would be carried in newspapers, directories, periodicals and local reference books. Here follow some examples of adverts for businesses trading in Tunstall around the first quarter of the twentith century.

Opposite: The High Street shop of Sillito & Son. At the height of their business there were other branches in Pittshill, Kidsgrove and Burslem.

STONE MASON.

ABRAHAM GREEN,

Marble, Stone, and Granite Carver,

HIGH STREET, TUNSTALL.

Monuments, Tombs, Tablets, Headstones,

GRAVESTONES, CHIMNEY PIECES,

AND ALL KINDS OF GARDEN VASES, &c.

On the most reasonable terms and on the shortest notice.

COUNTRY ORDERS PROMPTLY ATTENDED TO

HIGH ST. HIGH ST.,

TUNSTALL. TUNSTALL.

WILLIAM MOORE,

FUNERAL UNDERTAKER.

Newly-built Hearses and Mourning Coaches
ON THE SHORTEST NOTICE.

Wedding and other Carriages of first-rate quality, with Horses to match, for Hire on the most reasonable terms.

AN OMNIBUS MEETS EVERY TRAIN FROM THE SNEYD'S ARMS
Orders by Post promptly attended to.

A. W. MERRIDEW,

PRACTICAL

CHRONOMETER,

WATCH & CLOCK

MANUFACTURER,

(From Coventry.)

HIGH STREET, TUNSTALL.

A. W. M. having made arrangements for extending his Business, respectfully solicits an inspection from his customers and the public generally, who will find at his establishment the largest and most splendid assortment of CLOCKS, WATCHES, and JEWELLERY, in the Potteries.

A. W. M. has increased his stock of

CLOCKS, WATCHES, AND JEWELLERY,

Of the most Elegant Design and Workmanship. Every Clock and Watch Warranted for Twelve Months.

N.B.—All Repairs entrusted to his care will be Executed under A. W. M's own immediate inspection.

ELASTIC STOCKINGS (Silk & Cotton), Knee Caps, Ancle Socks, and Elastic Bandages, &c.; Abdominal Elastic Supports for relief during pregnancy; Trusses, Pessaries, Enema Syringes, Flesh Gloves, Waterproof Sheeting, and Air Cushions, &c., can be obtained at the Establishment of

S. BENNETT,

DISPENSING & FAMILY CHEMIST,

HIGH STREET, TUNSTALL.

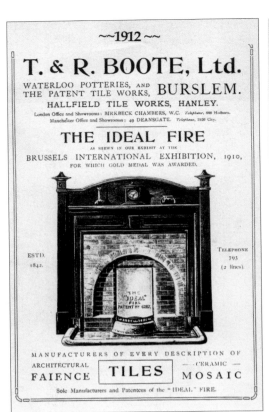
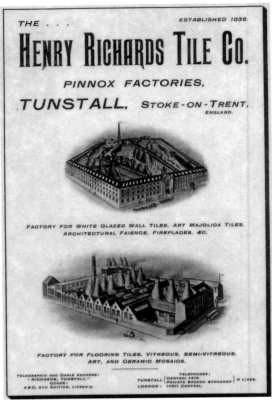

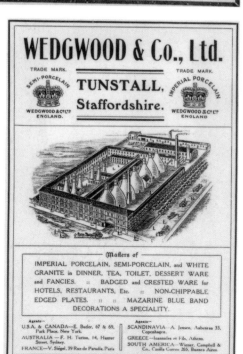

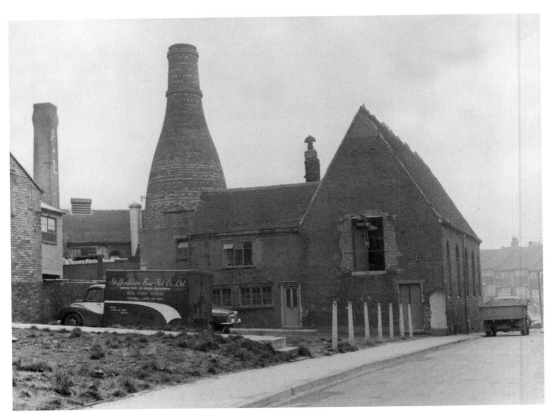

The Plex Street Pottery of the Staffordshire Tea Set Co. Ltd was to be found in the Clayhills area of Tunstall from 1947 to the late 1960s, when the area was redeveloped. Part of the building used by the pottery firm had been the original chapel used by the Catholic church for its first mission in 1853.

Opposite above: George Street Pottery can be seen here from Watergate Street, with the spire of St Mary's church in the distance.

Opposite below: The earthenware factory of Lingard & Webster began life in 1900 as the Swan Pottery in Hunt Street. It was demolished to make way for the new extension to Scotia Road and the redevelopment of the area where the police station is now situated.

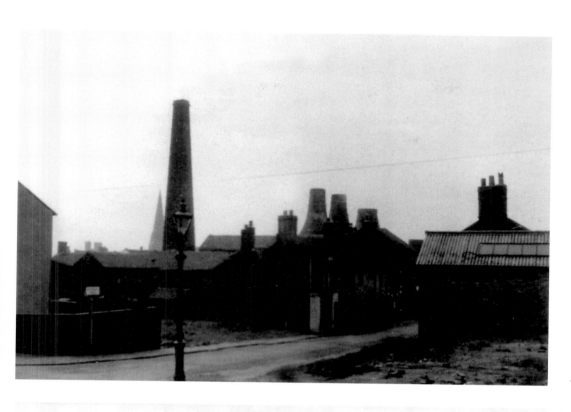

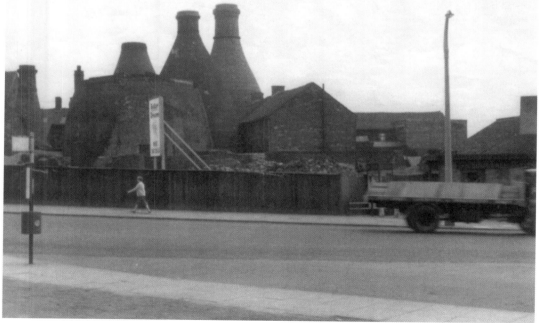

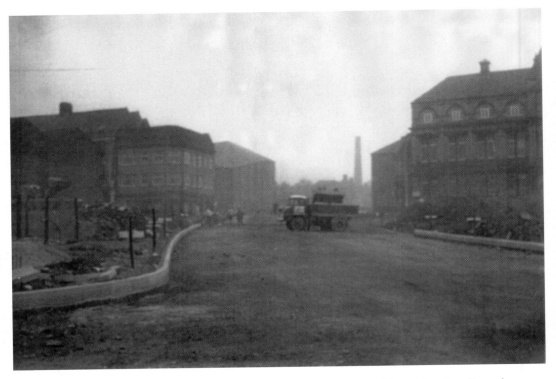

The new road system takes shape as kerbs are laid prior to the building up of the road surface. Beneath the ground the new underpass has been formed, leading from the Sentinel Building on the left to the Jubilee Buildings on the right. Traffic lights completed the work to the newly formed T-junction with The Boulevard (on the right).

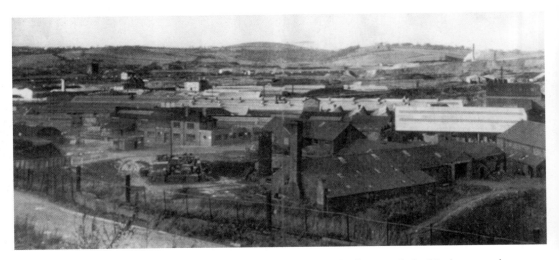

This heavily concentrated industrial scene in the Ravensdale Valley looks towards the Linehouses and Boathorse Lane area.

Religion in the Town

JESUS SAVES!

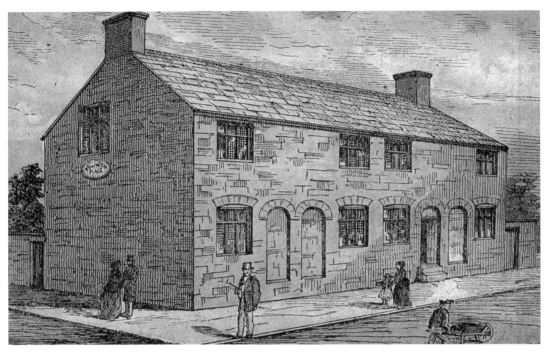

An artist's impression of the first Primitive Methodist chapel in 1811.

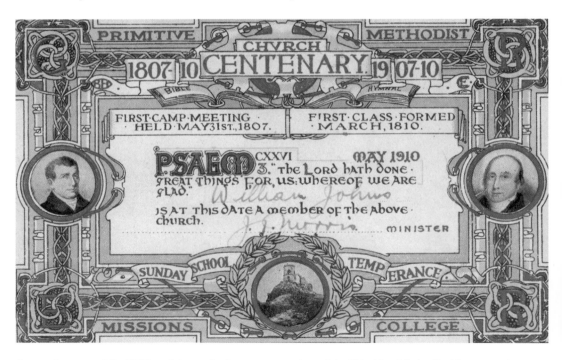

An enrolment card for William Johns, who became a member of the Primitive Methodist Movement in May 1910.

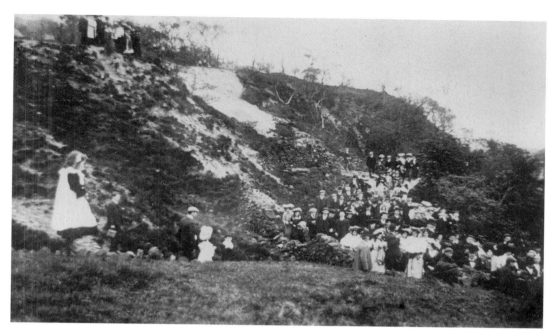

An early procession to a Mow Cop open-air meeting, *c.* 1907.

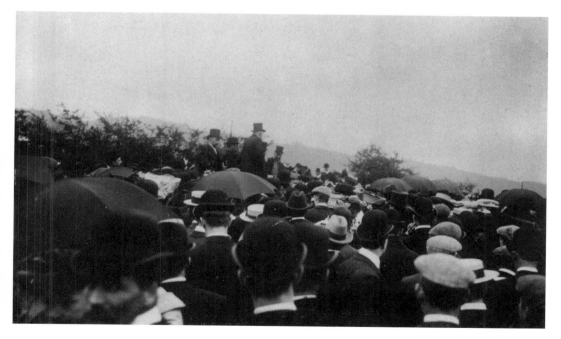

Another early meeting, when the rigours of the weather sorely tested the faithful.

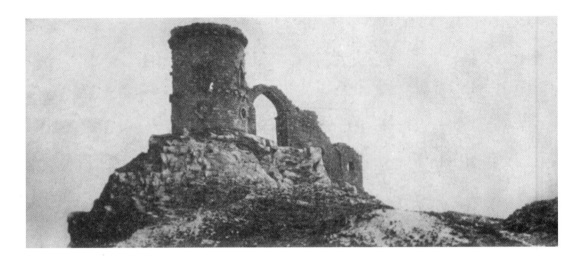

Top: Mow Cop Castle on a postcard. The folly has changed little over time.

Above: The Primitive Methodist chapel at Mow Cop.

Opposite above: A little souvenir of the Christian Endeavour Society, given by Pittshill Primitive Methodist chapel.

Opposite below: Tunstall Primitive Methodist chapel in 1834.

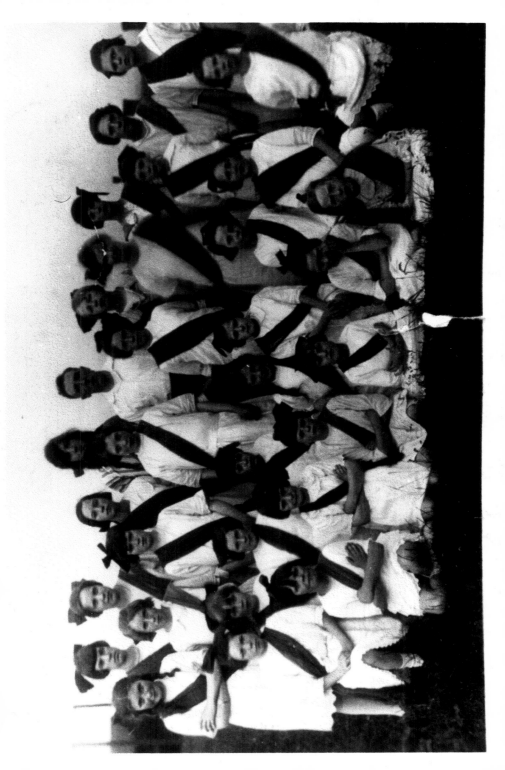

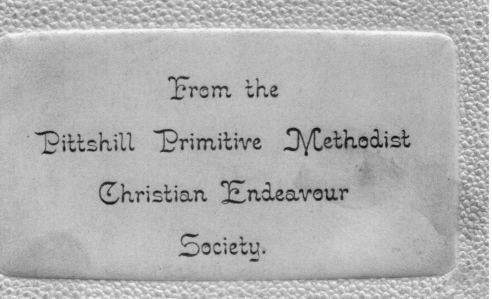

From the
Pittshill Primitive Methodist
Christian Endeavour
Society.

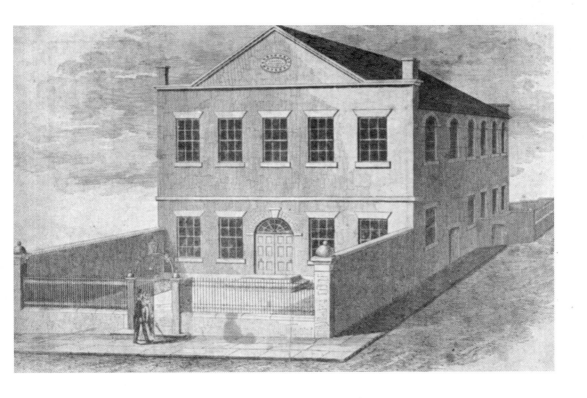

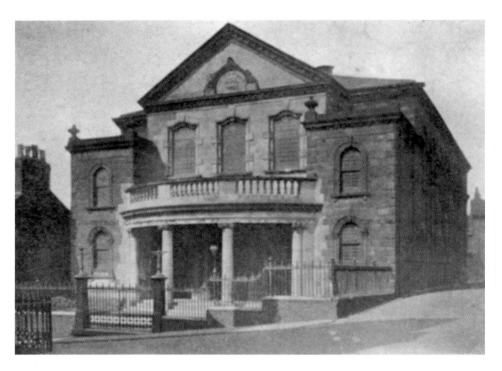

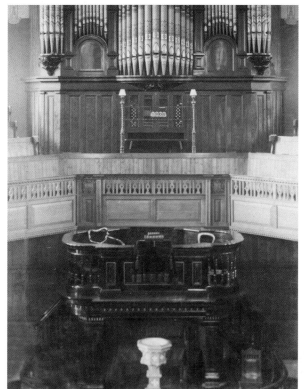

Above: The Jubilee church was completely renovated in 1904 and was regarded as one of the great centres of Primitive Methodism. It hosted several annual conferences of the Connexion between 1821 and 1925 and finally closed its doors in 1971 to be demolished as part of a major clearance and redevelopment scheme in the area. A new church complex was subsequently built and opened in 1975.

Left: The interior of the Jubilee church.

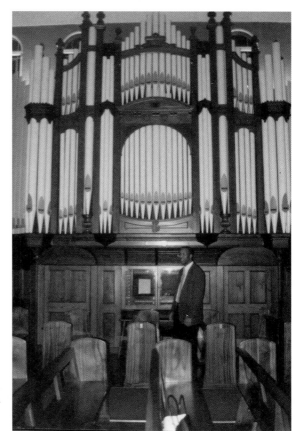

Right: The organ from Pittshill chapel was built locally by Messrs Steele and Keay in 1903. When the chapel closed in 1976 the organ was sold to the Catholic church of the Holy Family in Small Heath, Birmingham. It had a major overhaul and now lives on.

Below: Christ Church was consecrated in 1832. The tall spire was later removed because it was unsafe.

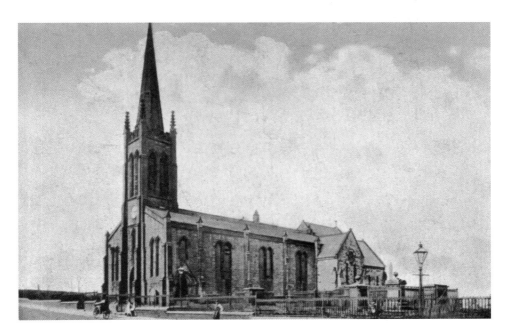

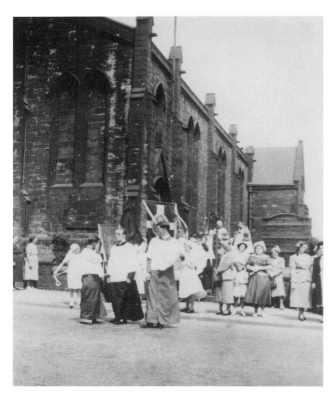

A May procession moves off from Christ Church onto High Street, led by acolytes and banner-bearers.

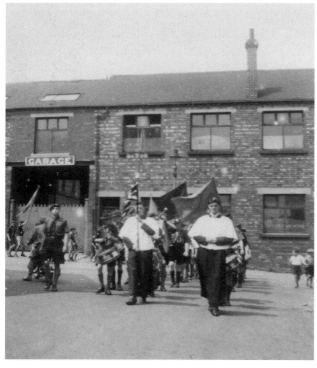

The procession is joined by the Scout Band and heads into Greengate Street from Furlong Road.

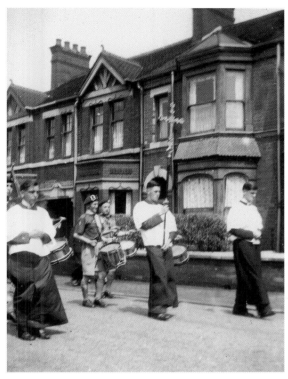

Left: Approaching the vicarage in Stanley Street.

Below: On High Street the crowds are out in good number.

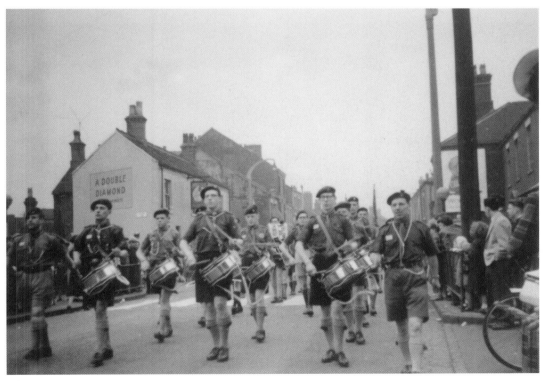

Children from the
Sunday school play
their part in the
procession…

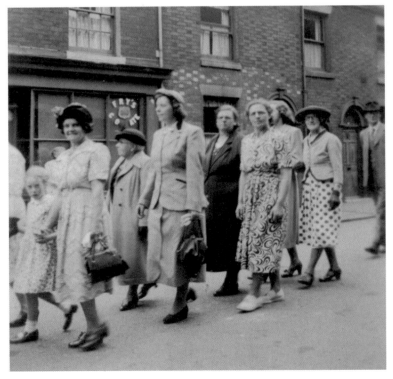

…as do the Mothers'
Union.

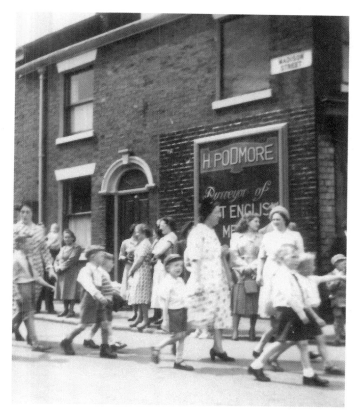

Left: Finally the procession emerges from Madison Street to return to Christ Church across the road.

Below: A Harvest Festival at the St Aiden's mission in Tunstall.

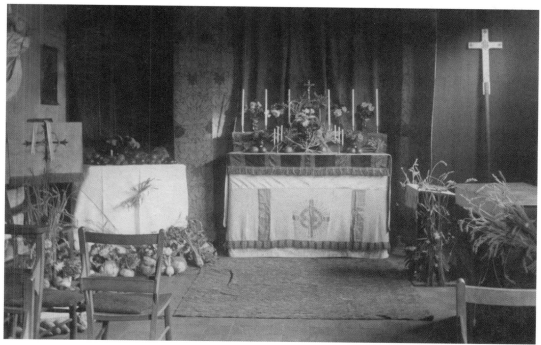

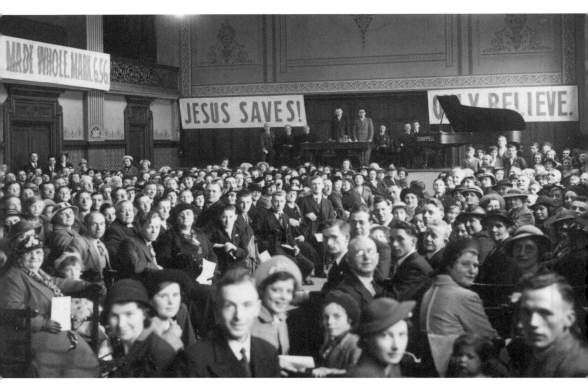

An Evangelical meeting, attended by the American preacher Lester Sumrall (1913-1996). He and his wife founded the Lester Sumrall Evangelical Association in 1957.

Opposite above: The Foundation Committee for the new Sacred Heart Catholic church. Front row, from left to right: William Harding, William P. McGough JP, John Fleming, the Revd P.J. Ryan, Mr Pitt, Tom harding. Second row: Mrs Higgs, Mrs Joe Butler, Mrs Quinn, Miss Davies, Mrs Pitt, Miss Regan, Miss Lilley, Mrs Harding snr, Mrs T. Harding, Mrs William Harding, Miss Margaret McGough. Third row: William Butler, Jim Harding, Mrs Gilligan, Mrs Davies, Mrs Baker, -?-, Miss Jane Carroll, Tom Mc Gough, Jason Quinn. Back row: Tom Ainsworth, John Harris, Sam Manifold, Clement O'Brien, Tom Gilligan, Joe Butler, John Tynan, Patrick O'Reilly.

Opposite below: Bishop Shine of Middlesbrough lays the foundation stone on 7 May 1925.

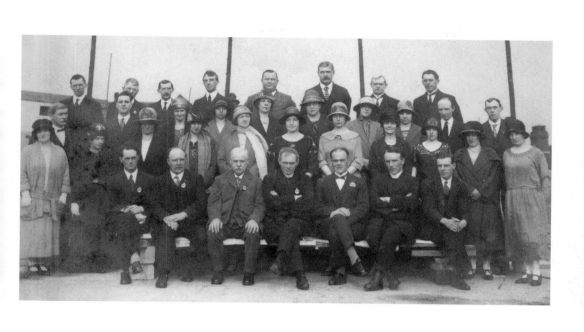

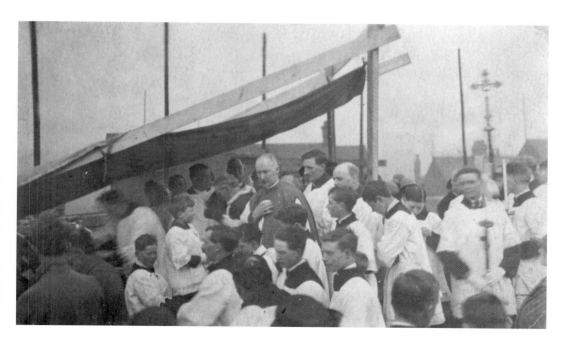

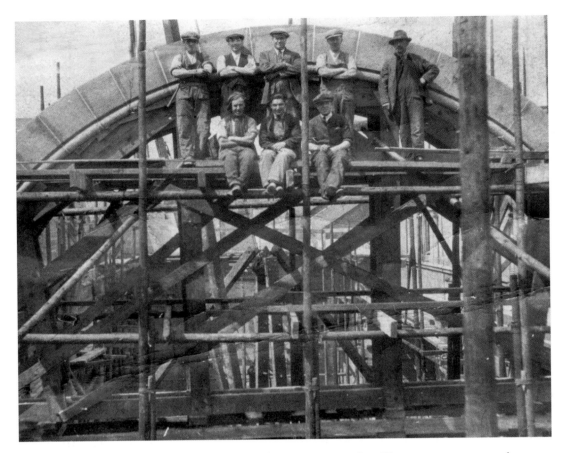

The huge copper-covered domes are supported by four giant stone arches. There were no power tools available, and no forklifts or hydraulic platforms. The scaffolding was made from stripped pine trees lashed together with hemp ropes with wedges driven in to keep them tight. It was the apprentice's job to go round each morning soaking the hemp and driving in the wedges.

Opposite above: This mighty bell still rings out each Sunday morning. On one side is cast:

MY NAME IS PATRICK. I WILL SING TO THE LORD AS LONG AS I LIVE. I WILL SING PRAISE TO MY GOD WHILE I HAVE MY BEING'. On the other side it says 'PRAY FOR US WHO HAVE GIVEN THE BELL TO THE PARISH AND FIRST RECTOR REV PATRICK J. RYAN ON THE CONSECRATION OF THIS CHURCH OF THE MOST SACRED HEART OF JESUS, AT TUNSTALL. 1928.

Opposite below: This was the high altar of St Mary's, the predecessor of Sacred Heart. It was in Sun Street (now St Aiden's Street).

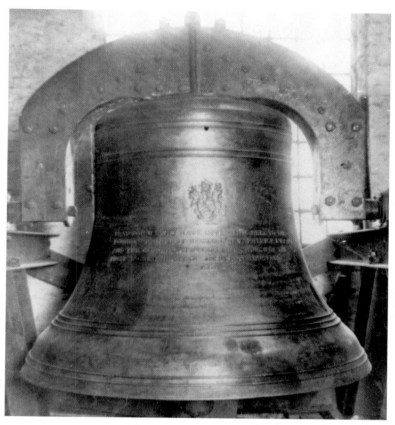

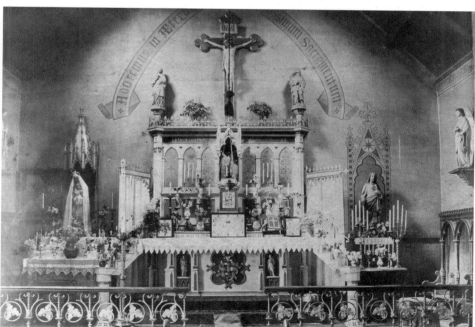

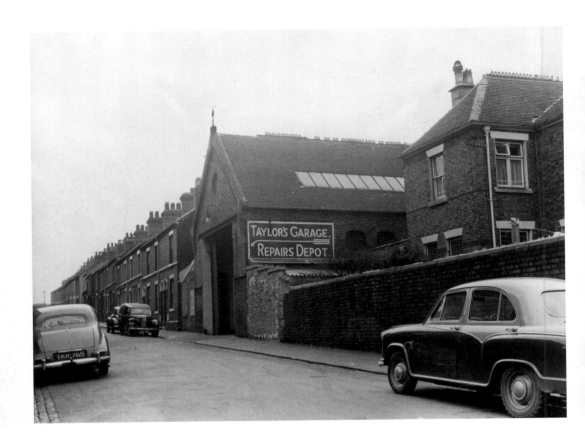

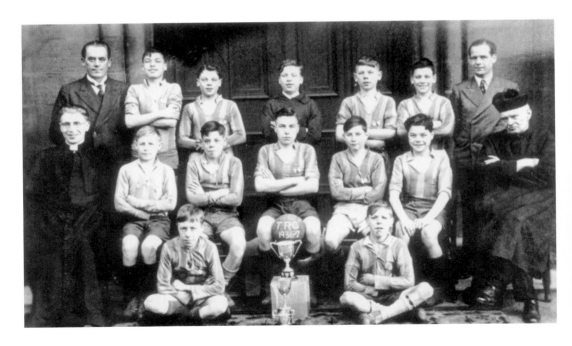

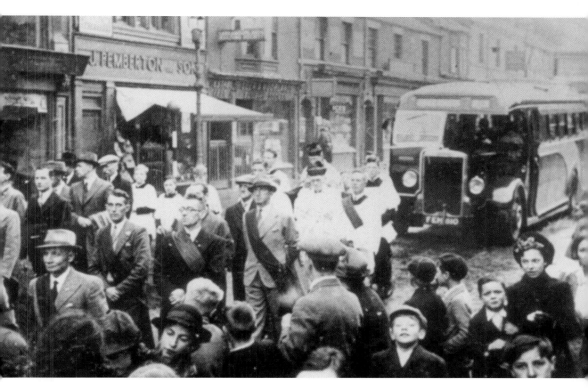

The tail end of a Catholic procession on High Street in the late 1930s.

Opposite above: After it closed, the church building became Taylor's Garage and the presbytery (on the right of the picture) was occupied by Mr Taylor and his family.

Opposite below: Tunstall Roman Catholic School inter-town football champions 1936/37.

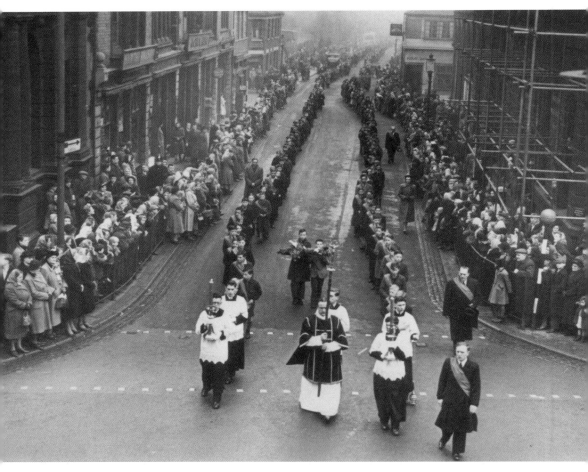

When Father Ryan died on 9 February 1951 he was eighty-five years old and had been in Tunstall since 1899. His funeral filled Sacred Heart church – a magnificent testimony to his ministry. A huge procession took place which brought Tunstall to a standstill. Crowds lined the route all the way to the cemetery at Clay Hills as Tunstall's faithful came to pay their respects. The procession was led by children and staff of Tunstall Roman Catholic School.

Opposite above: Altar servers and fellow priests follow on.

Opposite below: Men of the parish bore the simple coffin on their shoulders all the way across town.

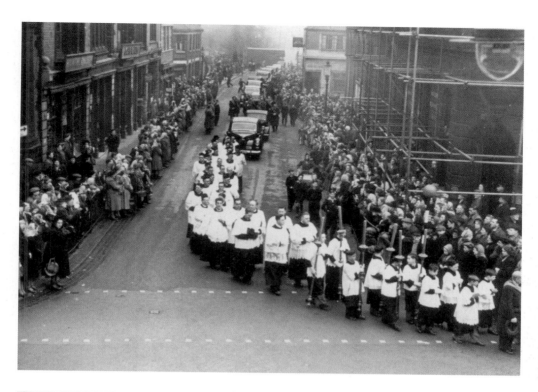

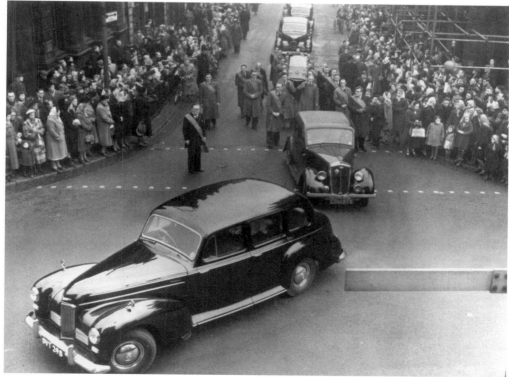

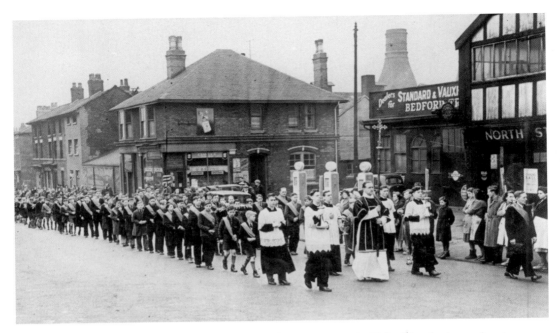

The procession proceeds along High Street, past Madeley Street towards Christ Church. A prominent stone cross marked the last resting place of Father Ryan, but this was replaced a few years ago by a smaller marble one following an act of vandalism.

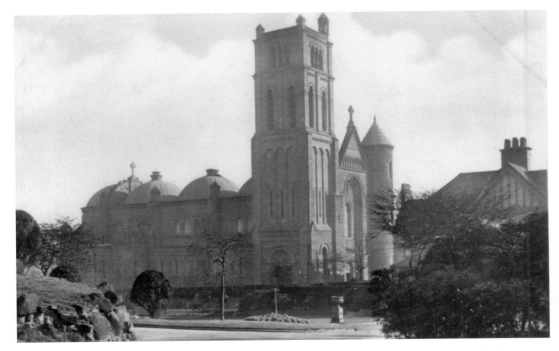

Sacred Heart was officially opened on 27 June 1930 and remains a testament to the dedicated Catholic families who help Father Ryan realise his dream in a period of great depression.

seven

Education

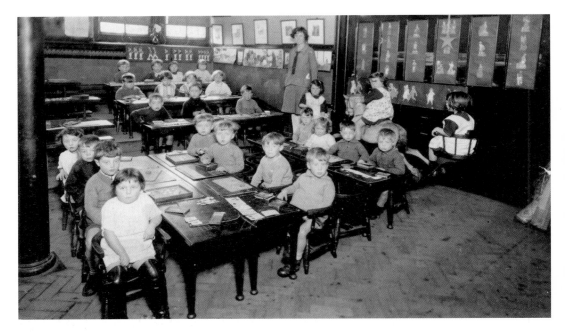

In this infants class at Forster Street School (*c.* 1926) there are triplets sharing the rocking horse and combined seesaw and, in the centre of the picture, there is a set of twins. The classroom is quite spacious with much activity on the surrounding walls.

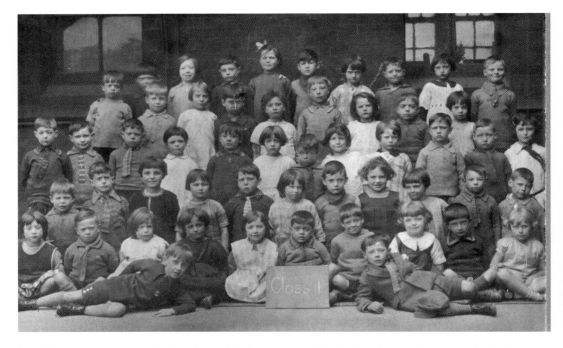

Class I seems quite large by today's standards. There are over fifty children in this photograph, including one future Lord Mayor of the city!

In recent years, Forster Street School has been used as a day centre for social services.

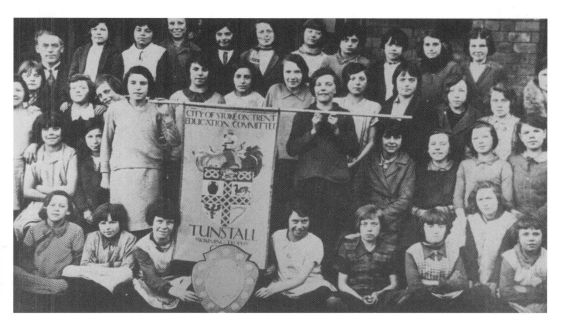

Tunstall has always had a reputation for breeding good swimmers. In this photograph, pupils from Tunstall Roman Catholic School celebrate winning the Tunstall Swimming Trophy.

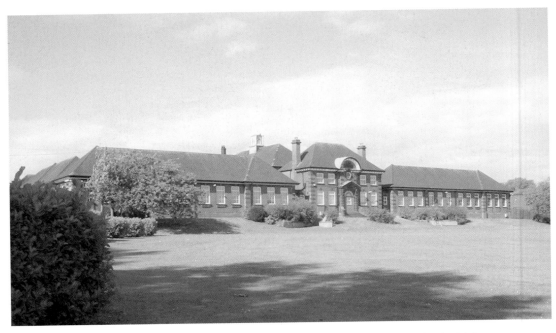

Brownhills High School for Girls opened in 1929. Ten years later they shared their school with boys from Hanley High School, whose own school had been damaged by subsidence. However, the boys and girls could not fraternise – they occupied the school in alternate sessions.

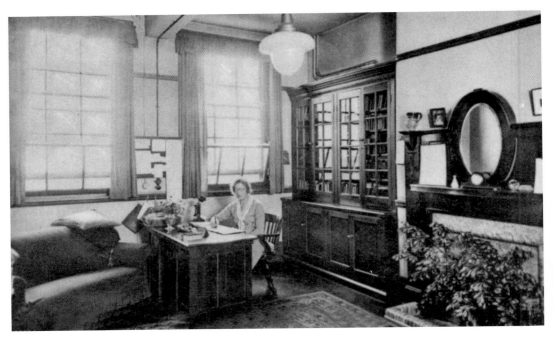

Miss Wilmott was a respected headmistress. She is seen here sitting at her desk and in front of her is a comfy-looking two-seater settee. In 1942, Miss Wilmott was succeeded by Dr Bright.

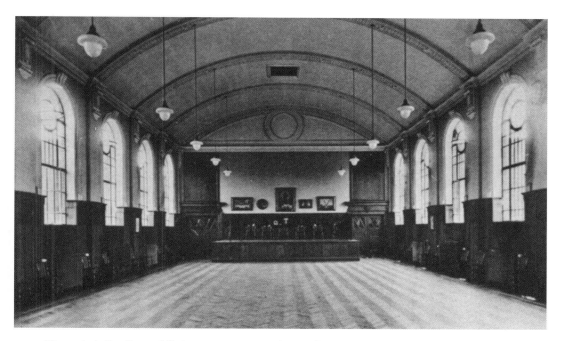

The main hall at Brownhills is very spacious, with a small stage at one end.

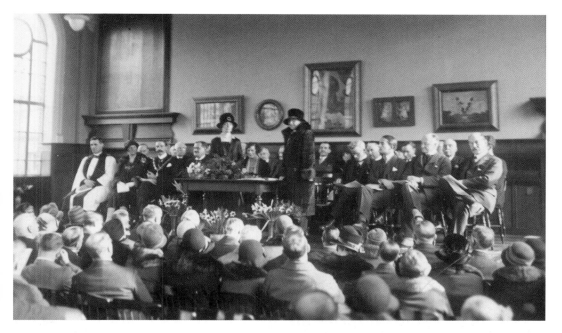

Here the stage is packed with dignitaries in around 1930 as two ladies rise to speak. There is a member of the clergy present and a civic leader in full regalia. The audience consists solely of adults – there is not a pupil in sight – so it is hard to imagine what the occasion is.

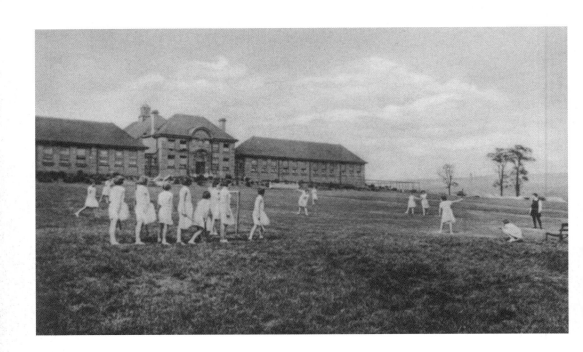

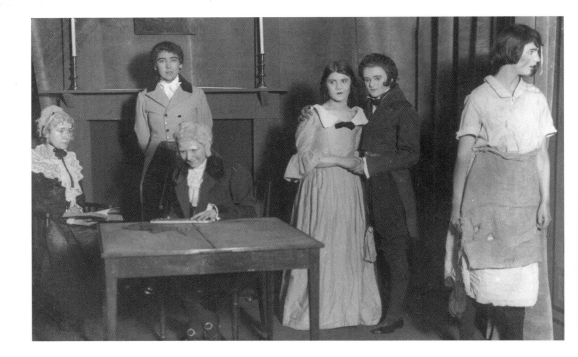

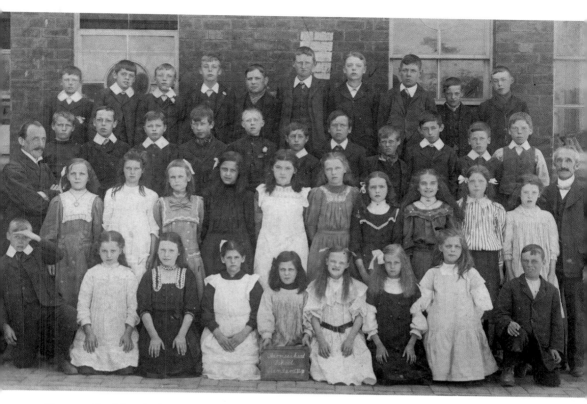

Forty pupils of Standard VI of Harriseahead School pose for the camera in around 1910.

Opposite above: Brownhills is bordered by much open space and here the girls are enjoying a game of rounders.

Opposite below: On 26th, 27th and 28th March 1931, pupils of Brownhills staged the play *Charles and Mary*. The cast list reads (from right to left);

Jane	Joan Parkes
Charles Lamb	Irene Glover
Mary Lamb	Marion Roberts
Mr Lamb	Lily Purcell
John Lamb	Joan Brander
Mrs Lamb	Margaret Chesterton

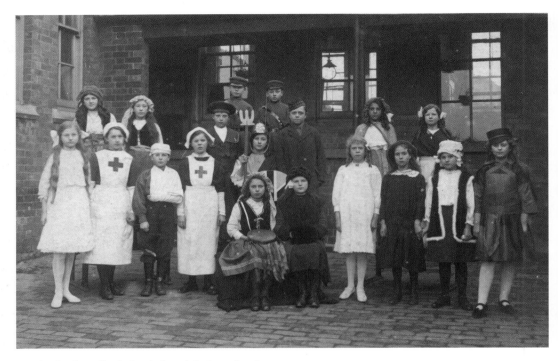

Harriseahead pupils obviously loved their performing arts.

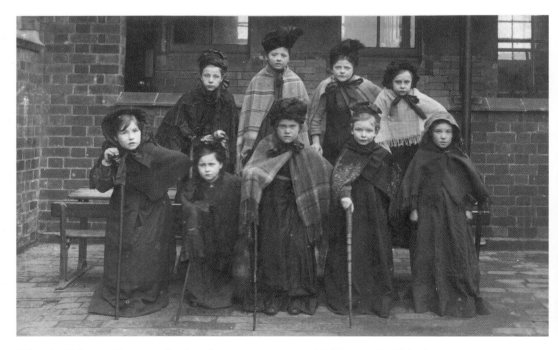

When I said 'you will stay at school until you get your sums right' I was only joking!

eight

Haywood Hospital

Howard and Richard Haywood were brothers who operated a brick and tile factory at Brownhills, on the edge of Tunstall, in the mid 1830s and '40s. They built Brownhills Villa in the late 1830s and it was here that Howard died in 1874. In his will he left £30,000 for the benefit of the sick poor of Burslem and the surrounding area and it was decided to build the Howard and Richard Haywood Hospital in Moorland Road, Burslem. The foundation stone was laid on 27 July 1886 and the finished building was adorned with the Haywood family crest in terracotta.

A new purpose-built hospital was built above Tunstall in the Stanfield area between 1927 and 1930, and the original hospital then saw life as an all-boys Junior Technical School in 1932. After the Second World War it was decided to expand the school and a new site was found, ironically across the road from the resited hospital in Stanfields! For several years pupils had lessons in both schools and were often required to make their own way from one site to the other, sometimes during lesson breaks. The Moorland Road site was eventually vacated in 1960 when the expansion of the new site was finally completed, by which time the school name had changed to Stanfield County Technical School. In 1961 the Education Authority decided on a further name change to Stanfield Technical High School. The Moorland Road building has since had a chequered life, mainly as an annexe of Stoke-on-Trent College, and today it is the headquarters of the Burslem Community Development Trust.

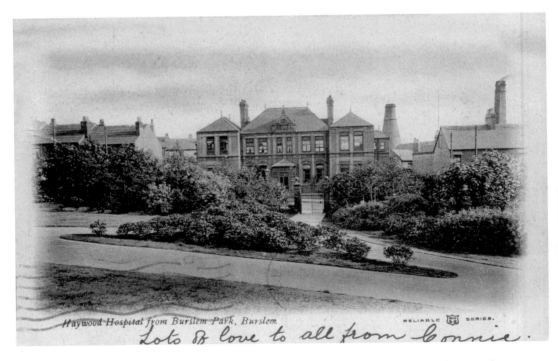

Haywood Hospital from Burslem Park, Burslem.

This postcard was sent to America in 1903. The view is believed to be slightly earlier and gives a clear view of the hospital from Burslem Park.

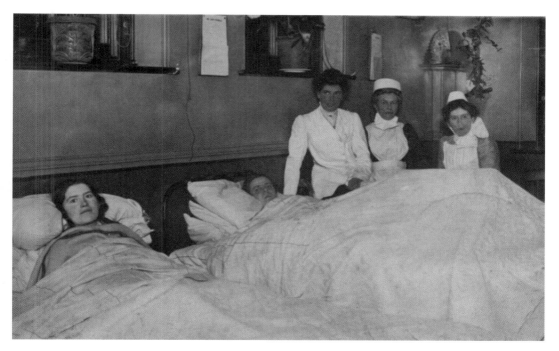

A scene in one of the small wards of the original Haywood Hospital, *c.* 1920.

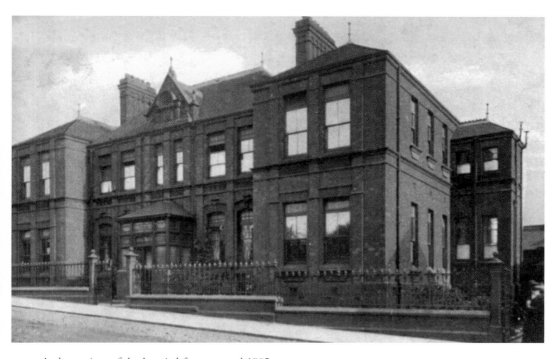

A closer view of the hospital from around 1905.

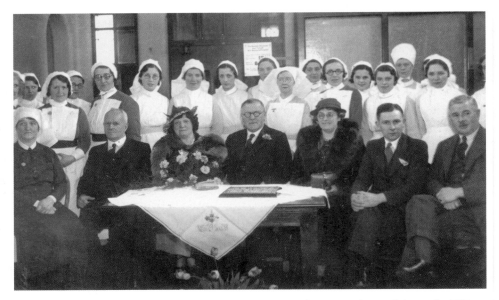

The Haywood Hospital also underwent name changes over the years. This card shows the VIPs of the Burslem Haywood & Tunstall War Memorial Hospital attending the ceremony for the opening of the new tennis courts on 16 April 1935.

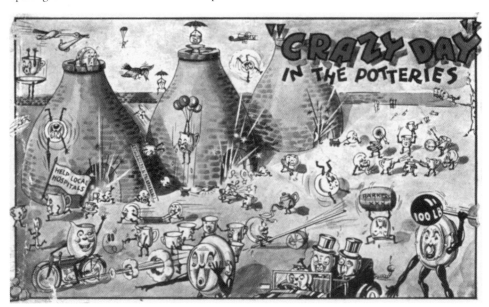

Fundraising was an essential way of life for the hospital and the proceeds from the sale of this card, called 'Crazy Day in the Potteries', were to 'be donated to the effort in aid of the Burslem Haywood & Tunstall War Memorial Hospital'. Apart from the obvious bottle ovens, the sketch contains other local references. One figure holds aloft a beer barrel bearing the name Parker's. Parker's Celebrated Ale was a well-known drink brewed in Burslem. On the fuel tank of the motorbike is the word 'Michelin'. The Michelin Tyre Co. Ltd opened their first British plant in Stoke-on-Trent in 1927.

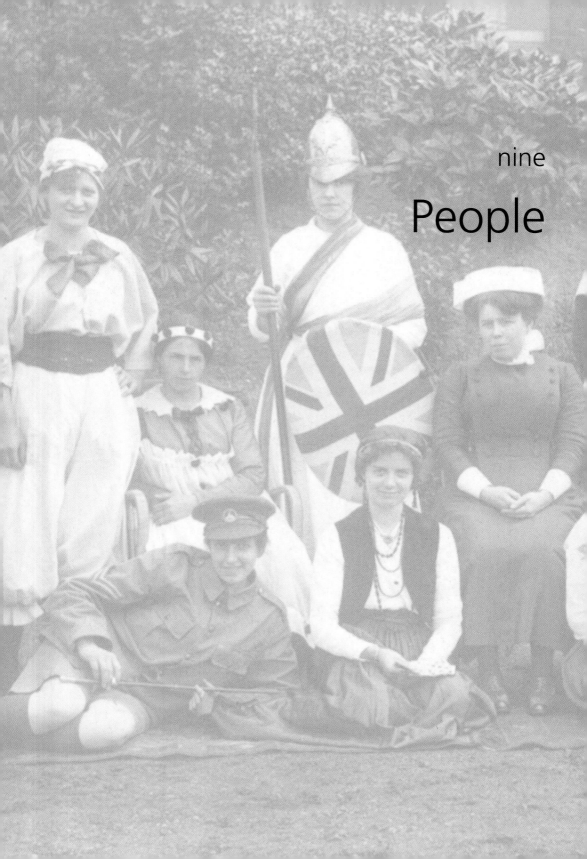

nine

People

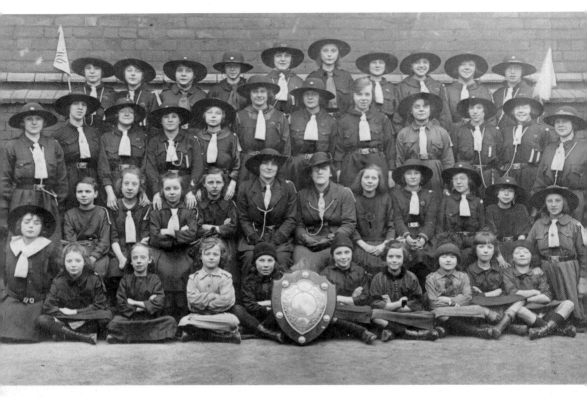

A well turned-out group of 1st Tunstall Girl Guides, possibly from around 1920.

Opposite above: In this early card the team is identified as Tunstall FC, but the only player mentioned is Tom Purcell, seated third from the right on the front row.

Opposite below: Tunstall's cricket ground was on Brownhills Road, close to the junction with Canal Lane. The teams provided much entertainment on the local sporting scene prior to the First World War and drew large crowds. The club even employed its own professional, Cecil Parkin, who is in the record books as having taken 120, 105 and 110 wickets in successive seasons for Tunstall. He later went on to play for Lancashire and England. Unfortunately the club did not reopen after the war, although the game continued to be played in the town, as can be seen from this relaxed team photograph by T.H. Pemberton.

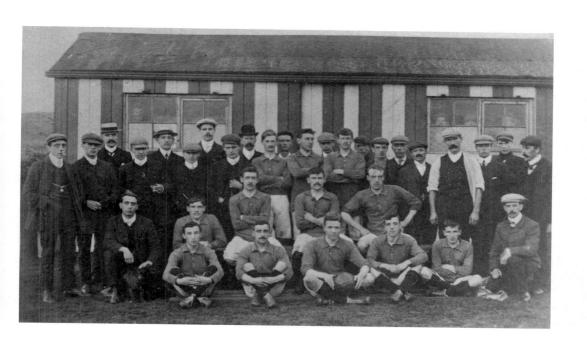

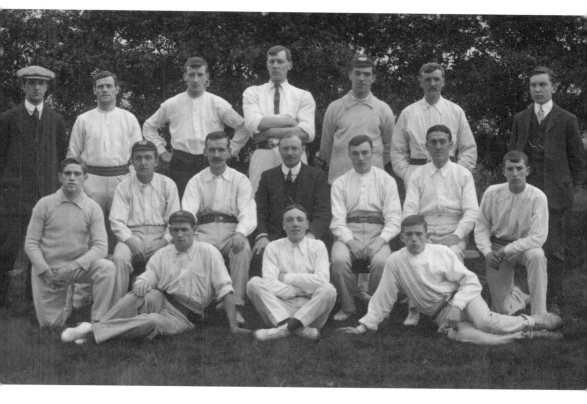

Before the advent of the motor car – when the cart was king – the townspeople would have had need of horses. This in turn provided its own growth industries – horse dealers, livery stables, saddleries and farriers, for example.

These adults are resplendent in their dressing-up outfits as they celebrate 'Peace' in July 1919.

This photograph shows a very large, smartly dressed group of men and boys in a pipe and drum band. There are rifles stacked in two groups of three at each end of the picture and the band appears to have been photographed outside St Mary's Catholic church in Sun Street (now St Aiden's Street), with Father Ryan sitting in the middle of them.

A group of men look happy to pose for this photograph outside the Dog and Pheasant in Mount Street (now Knight Street), *c.* 1910. The landlord, dressed in an apron, stands ready to dart back inside as they look a thirsty bunch. The interior of this public house was removed in 1982 and now forms a display in the community history section of the Potteries Museum in Hanley.

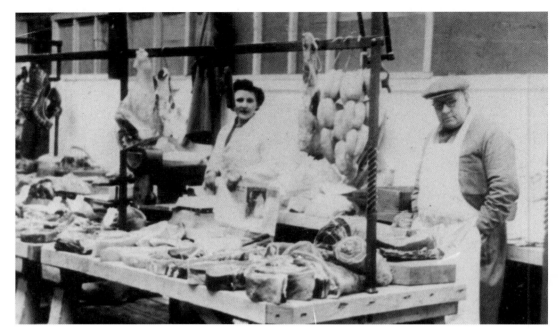

John Davies stands behind his butcher's stall in the Market Hall. He worked long after retirement age and died in 1964, aged eighty–five.

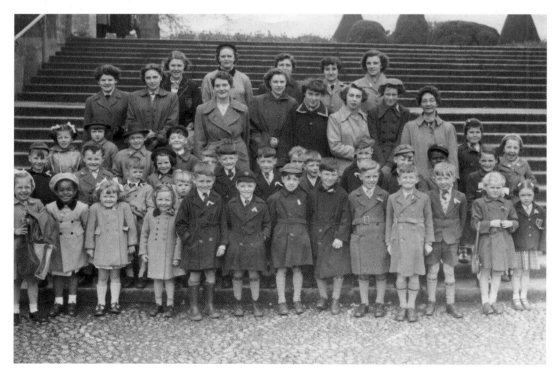

Trentham Gardens was the destination of this Sunday school outing from Christ Church, *c.* 1955.

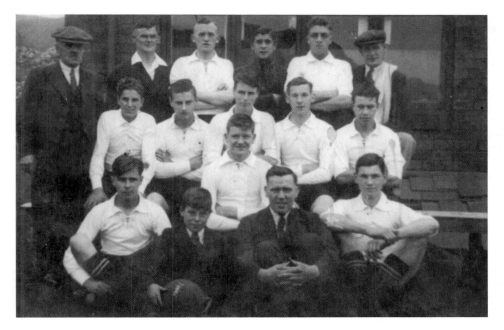

An early picture of Goldenhill Wanderers FC from around 1930, when Bill Ballard played in goal.

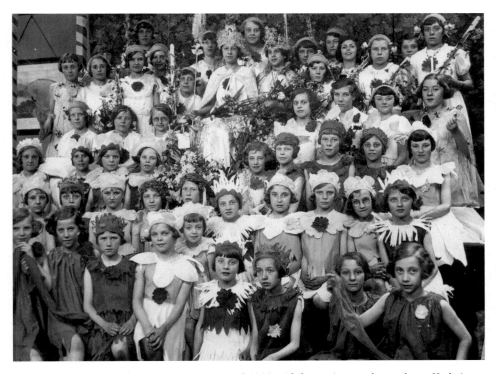

Here is the Summerbank May Queen in around 1932 with her retinue and attendants. Kath (now Littler) was the newly crowned queen and Marjorie (now Thursfield) was the retiring queen.

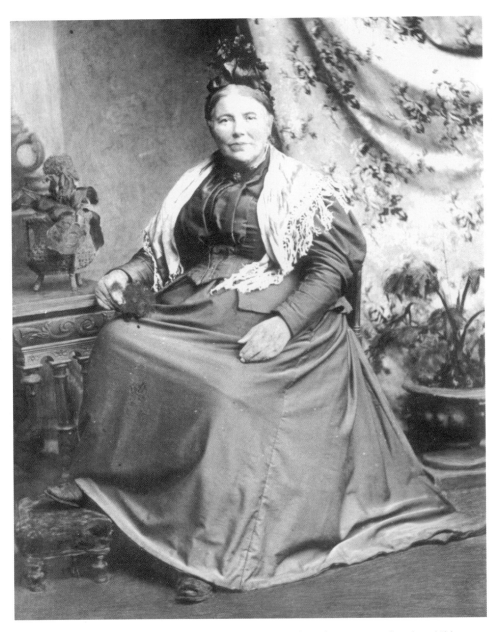

This imposing lady is Mary Ann (Fanny) Brennan (*née* Toole). She was one of twelve children born to Luke Toole and Ellen Finn, who originated from Ballybrommell in Ireland. Fanny came to England by boat at the age of twelve. What she did not know at the time was that her future husband, John Brennan, was also on the boat. After they married they had eleven children between 1863 and 1884. Descendents of this family still live in Tunstall. Despite her lack of formal training or qualification, Fanny was often called upon to perform the tasks of a midwife by assisting Dr Garvey, one of the local doctors, in bringing babies into the world. Dr Garvey often said that Fanny would have a lot of babies waiting for her in heaven as she always baptised those who were in danger of death.

ten

Absolom
Reade Wood

A.R. Wood (20 December 1851 – 21 December 1922) belonged to the family of noted Burslem potters upon which Arnold Bennett, the noted local author, based his characters for the *Clayhanger* trilogy. Having trained as an architect, Wood became articled to Robert Scrivener of Hanley. A notable design of the Scrivener practice was the Queens Hotel in Hanley, later to become the Town Hall.

In 1874, Wood went into practice on his own account in Hanley and later formed a partnership firstly with J. Hutchings and then with a Mr Goldstraw. Some 130 years later, the firm of Wood, Goldstraw & Yorath is still prominent amongst Potteries architects and has many notable designs and projects to its credit.

A.R. Wood moved his new practice to Butterfield Place in Tunstall and, in 1875, he was appointed to the part-time position of surveyor to the local Board of Health, a position he held until 1910. He was a prominent and respected member of the Methodist church and attended Hill Top chapel in Burslem and later Longport United Methodist chapel, where there is a plaque to his memory.

Many of the public buildings in Tunstall were built to Wood's designs and he was also responsible for many other prominent works. The following list is not exhaustive but does give a brief insight into this man's capabilities which, to date, have largely remained unrecognised; 1875 – Primitive Methodist School, Tunstall; 1876 – Baptist Tabernacle, Burslem; 1878 – Congregational church, Tunstall; 1878 – Primitive Methodist chapel, Wolstanton; 1885 – Town Hall, Tunstall; 1885 – Congregational church, Burslem; 1886 – St Andrew's church, Porthill; 1885-86 – transepts and chancel of Christ Church, Tunstall; 1887-97 – free library, science and art schools, fire station, public library and museum, Tunstall; 1889 – Victoria Institute Jubilee Buildings, Kidsgrove; 1893 – clock tower, Tunstall; 1906 – façade of Jubilee Wesleyan Methodist chapel, Tunstall; 1905-07 – School of Art, Burslem; from 1907 – sewage disposal works, cemetery chapel and lodge, public park, Drill Hall, High Street School, Chell School and many more buildings in and around Tunstall.

Wood was a friend and contemporary of Arnold Bennett's father, Enoch. Together they, with other interested parties, were responsible for creating *The Staffordshire Knot* as a weekly journal in 1882. By 1885 it had changed to a daily paper but had to cease publication in 1892.

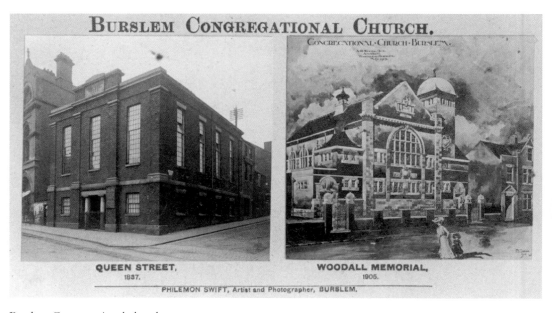

Burslem Congregational church.

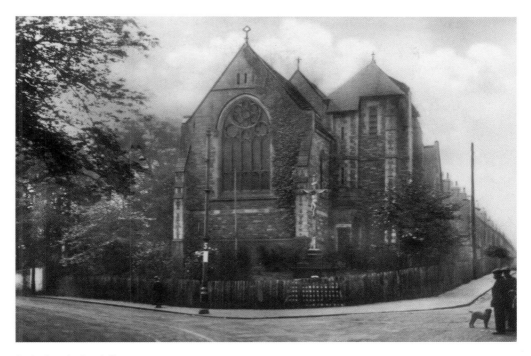

St Andrew's, Porthill.

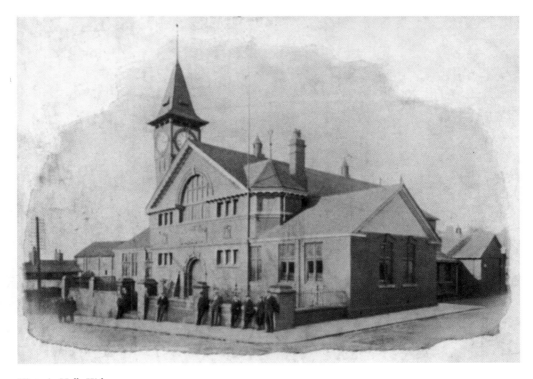

Victoria Hall, Kidsgrove.

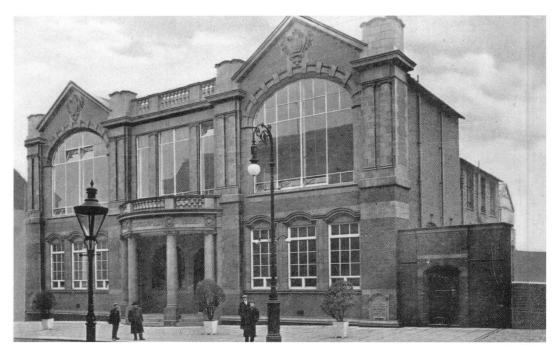

School of Art, Burslem.

Drill Hall, Burslem.

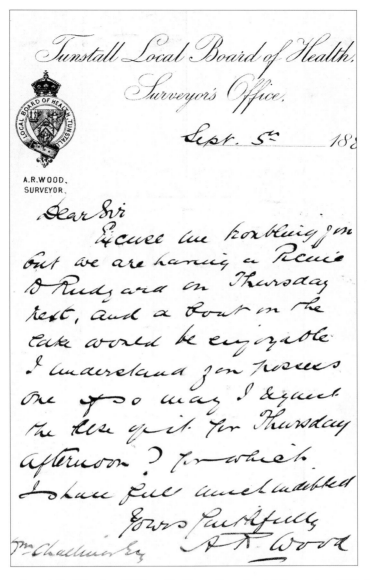

This is a letter from A.R. Wood to William Challinor, Esq., dated 5 September 1884. It reads:

Dear Sir,
Excuse me troubling you but we are having a Picnic at Rudyard on Thursday next, and a boat on the lake would be enjoyable.
I understand you possess one, if so may I request the use of it for Thursday afternoon? For which I shall feel much indebted.
Yours faithfully,
A.R. Wood.

The Challinors were another notable family in Potteries society in the late nineteenth and early twentieth centuries. Various members were solicitors, colliery owners and earthenware manufacturers.

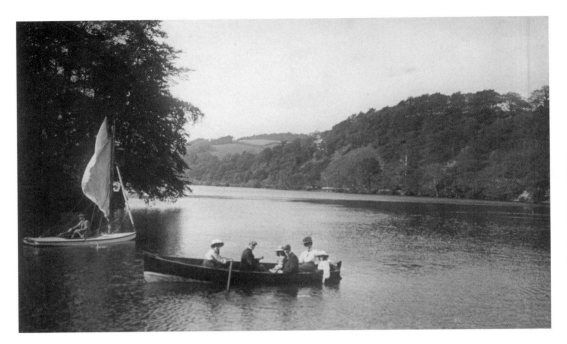

A family out on their boat on Rudyard Lake.

eleven

Surrounding Districts

Tunstall is surrounded by small villages and hamlets. As the town grew, so the distance between the villages became less and less. The following selection of postcards gives a glimpse of life just outside Tunstall.

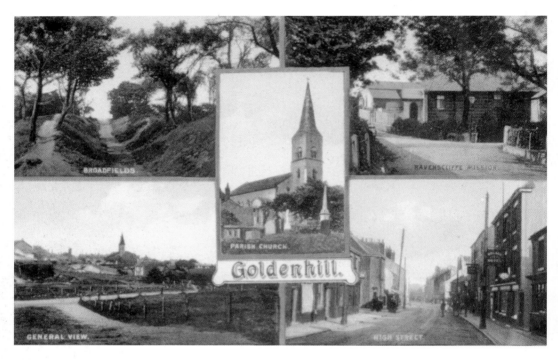

Above: In the centre of this multiview card is the church of St John, opened in 1841. Principal landowners in the village were Sir Smith Child Bart, John Henshall Williamson and Sir Thomas Fletcher Boughey Bart.

Left: Goldenhill lies to the north of Tunstall and is the highest village in the city. At the far end of High Street, at the top of Kidsgrove Bank, were the tramsheds and terminus. The Hanley to Goldenhill line was opened in 1900 and ran until 1928. This card was posted in 1904 but shows a much earlier view of a tram heading down to the town.

Opposite: These three little girls pose happily for the photographer outside their Goldenhill home.

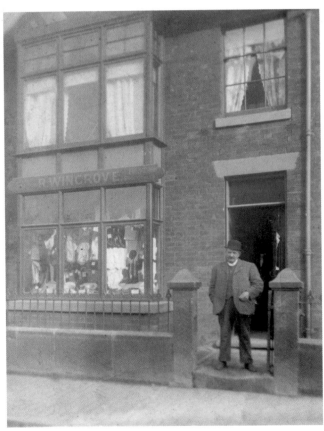

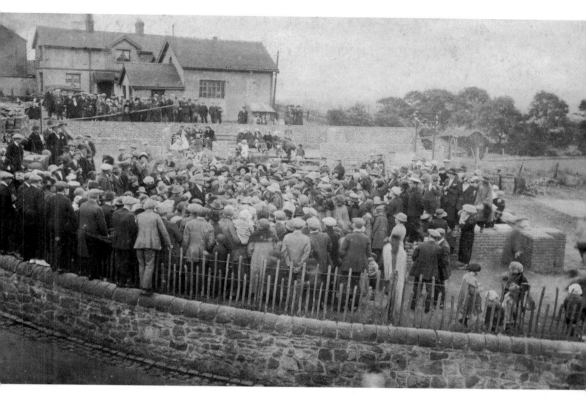

The crowds came out in Harriseahead to see the laying of the foundation stone for the Primitive Methodist memorial chapel in around 1920.

Opposite above: Goldenhill Station was on the North Staffordshire Railway's loop line. In the far distance on the horizon is the church of St James at Newchapel. James Brindley, the great canal engineer, is buried here.

Opposite below: This shop front in Brindley Ford shows the business of R. Wingrove, a boot and shoe dealer, in around 1910.

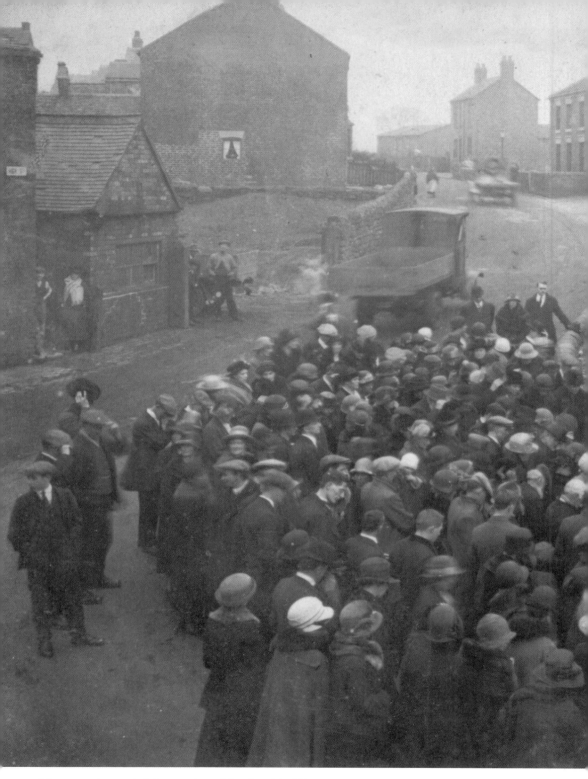

More crowds attended the opening of the chapel in 1924.

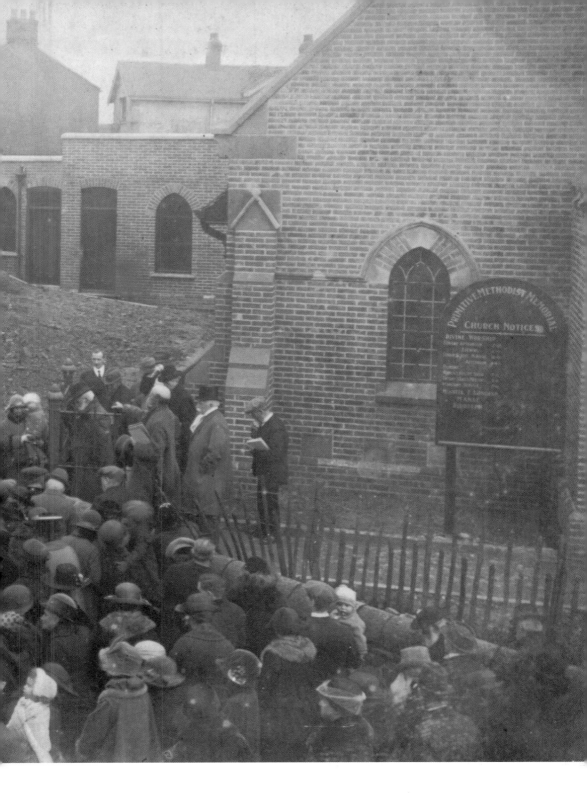

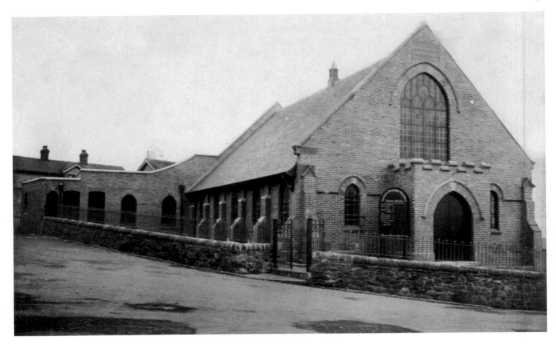

The chapel in all its glory sits on the corner of Chapel Street and High Street in Harriseahead.

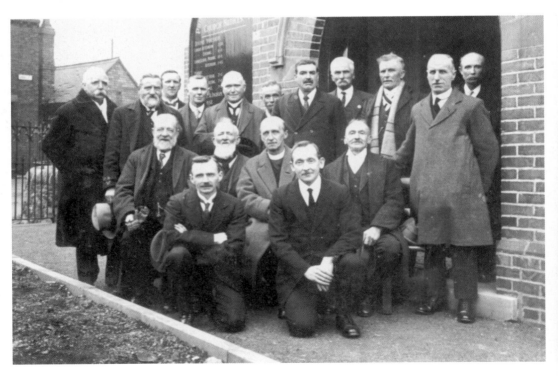

The committee of elders pose proudly for the opening event.

twelve

Not this
Tunstall!

Directories and gazetteers list approximately ten Tunstalls in England. They range from small villages to large towns and are spread across the north, south, east and west of the country. Here are examples of some of the other Tunstalls.

Tunstall-With-Dinningworth, Suffolk

This Tunstall is referred to as a parish, little more than a village, seven-and-a-half miles north-east of Woodbridge.

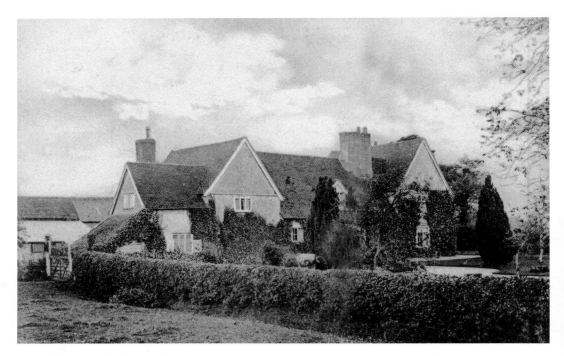

The Gables is an Elizabethan timber-framed farmhouse with one side brick-nogged. It is situated to the south of the church of St Michael.

Opposite above: This is the church of St Michael, containing beautiful carvings and artefacts dating back to the seventeenth century. A previous church is known to have existed on this spot in the fourteenth century.

Opposite below: The Green Man Hotel. The present building, built in around 1900, replaced a much earlier version dating back to the eighteenth century. It has always enjoyed a reputation as a 'refreshment house' and in 1908 it was listed in Kelly's Directory as 'catering for cyclists and parties, with accommodation'.

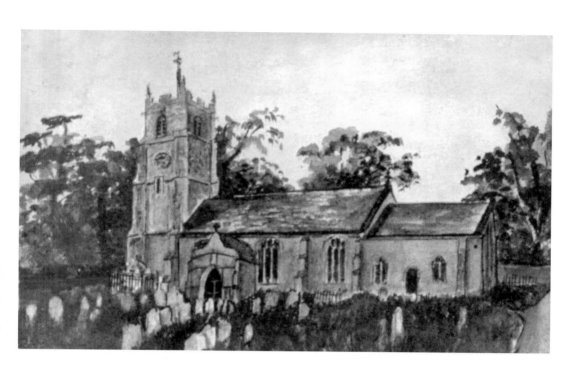

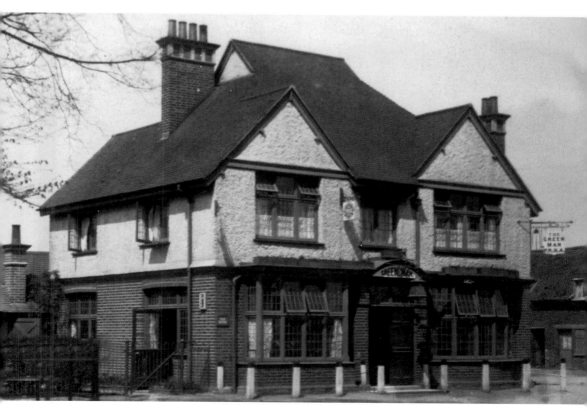

Tunstall, Lancashire

This community is near Kirby Lonsdale, ten miles south-west of Lancaster. Charlotte Bronte attended school here and this Tunstall is the 'Brocklebridge' of *Jane Eyre*.

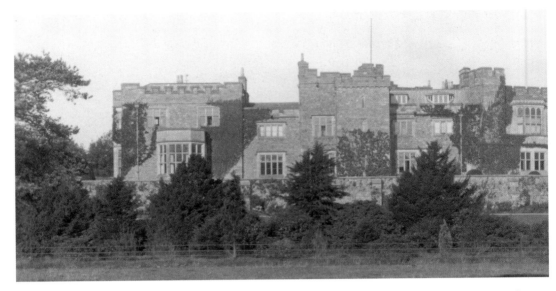

Thurland Castle dates from the fourteenth century and lies in thirteen acres of parkland near the head of the Lune Valley. It was besieged and partially demolished during the Civil War of 1643 and rebuilt as a country house between 1809 and 1829. Further extensive rebuilding took place in the 1880s following a large fire. The castle has recently been refurbished and converted into luxury apartments.

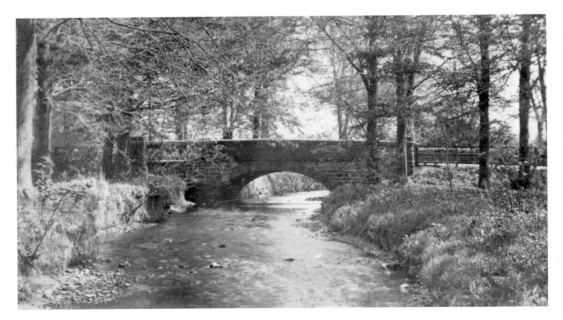

Cant Bridge is situated on the River Greta at Tunstall.

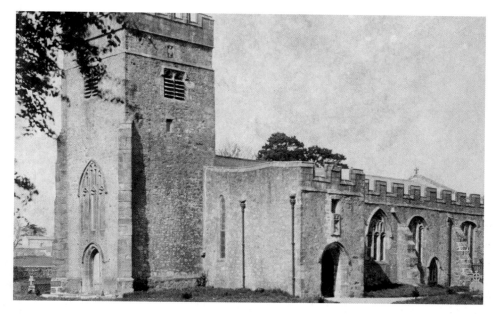

St John the Baptist church. There is mention of a church in this particular Tunstall as far back as 1069.

Tunstall, near Sittingbourne, Kent

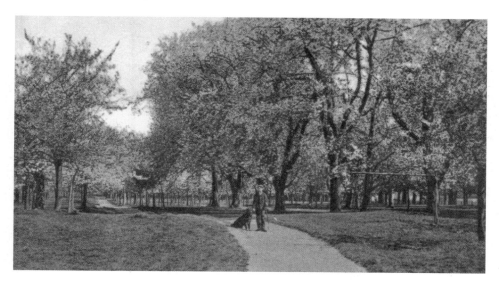

A cherry orchard in blossom. This appears to be Tunstall in Kent, close to Sittingbourne.

By far the largest and most important Tunstall from an industrial perspective is the one which is the subject of this book. I hope I have given you a taste of this and made a small contribution to the social history of the town.

Other local titles published by Tempus

Newcastle-under-Lyme Revisited

NEIL COLLINGWOOD AND GREGOR SHUFFLEBOTHAM

This fascinating collection of over 200 archive images, many previously unpublished, explores the historic market town of Newcastle-under-Lyme, from Victorian times to the present day. The buildings, shops and industries of the town are described, as well as transport, local schools, the services and of course local people, always at the heart of this strong community.

0 7524 3672 4

Burslem

THE BURSLEM HISTORY CLUB

Using over 200 evocative images, this book documents the people and places of Burslem, the Mother Town of the Potteries. The Burslem Angel and the Old Fire Station are featured, as well as many of the grand Victorian buildings and the factories, schools and churches of the area. Many significant events are also recorded, including the Sneyd Pit disaster of 1942.

978 0 7524 3456 8

Voices of the Potteries

ALAN TAYLOR

This evocative and often humorous compilation of reminiscences records life as it used to be in the Potteries. A comprehensive and fascinating view of life is depicted including experiences of childhood, work, the war years and the village community. Memories make us what we are. This is the Potteries remembered in the words of its own people.

0 7524 2276 6

Biddulph Volume II

DEREK J. WHEELHOUSE

This second absorbing collection of over 200 images traces some of the changes and developments in Biddulph over the last century. Drawn from the archives of the Biddulph & District Historical and Genealogical Society, this valuable pictorial history highlights some of the events that have taken place during this time as well as exploring aspects of everyday life, from schools and shops to transport and modern restoration programmes.

0 7524 3463 2

If you are interested in purchasing other books published by Tempus, or in case you have difficulty finding any Tempus books in your local bookshop, you can also place orders directly through our website

www.tempus-publishing.com